ZWELETHU MTHETHWA

ZWELETHU MTHETHWA

Interview by Isolde Brielmaier Essay by Okwui Enwezor

aperture

From the series Interiors, 1995–2005, and Empty Beds, 2002

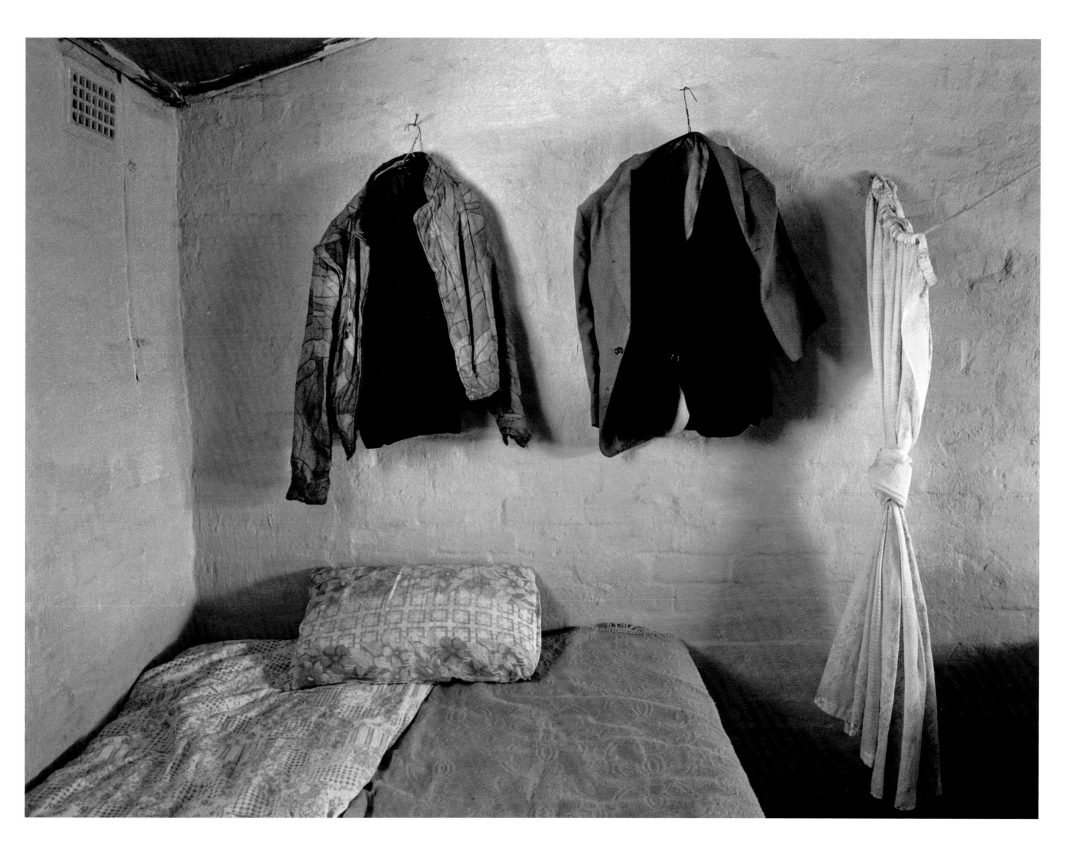

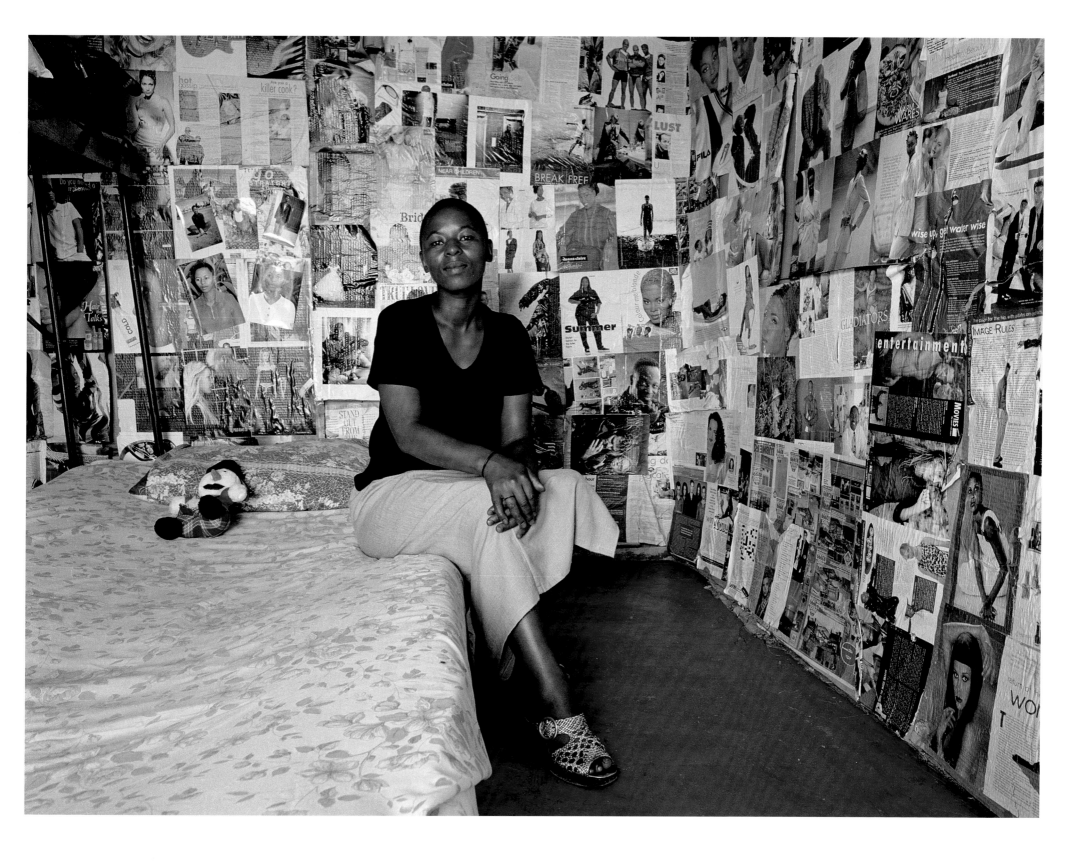

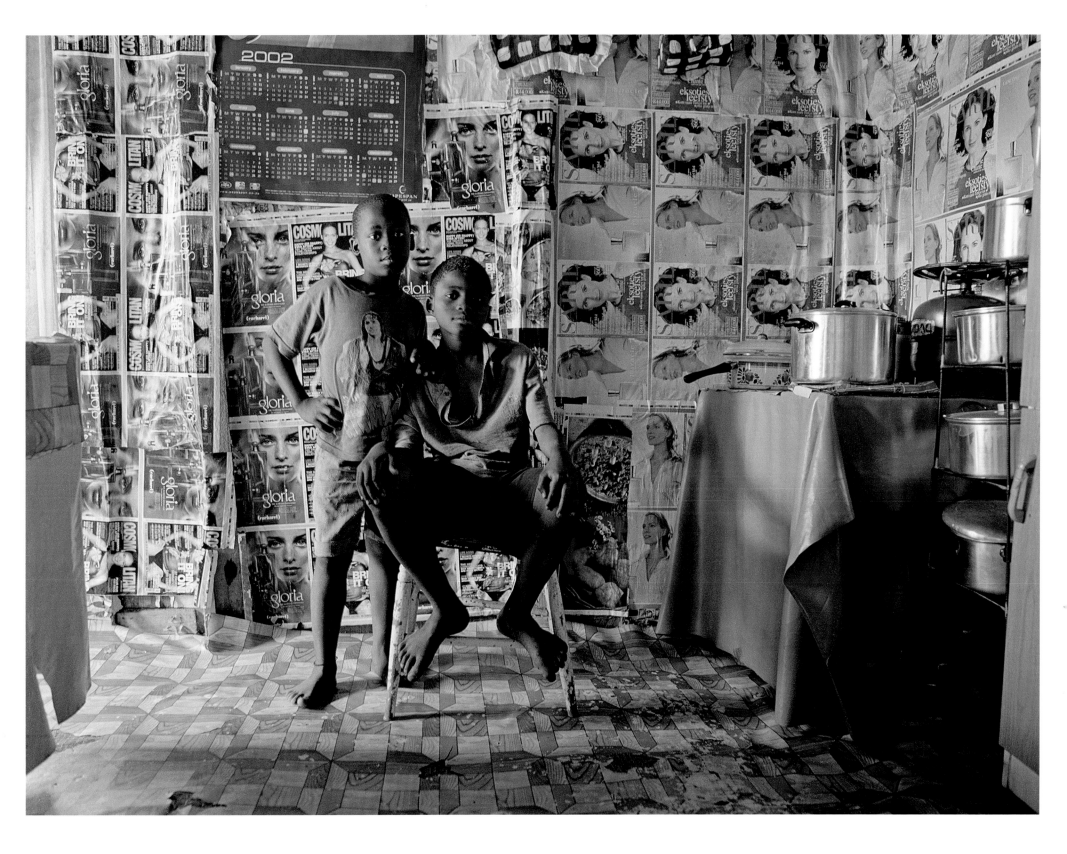

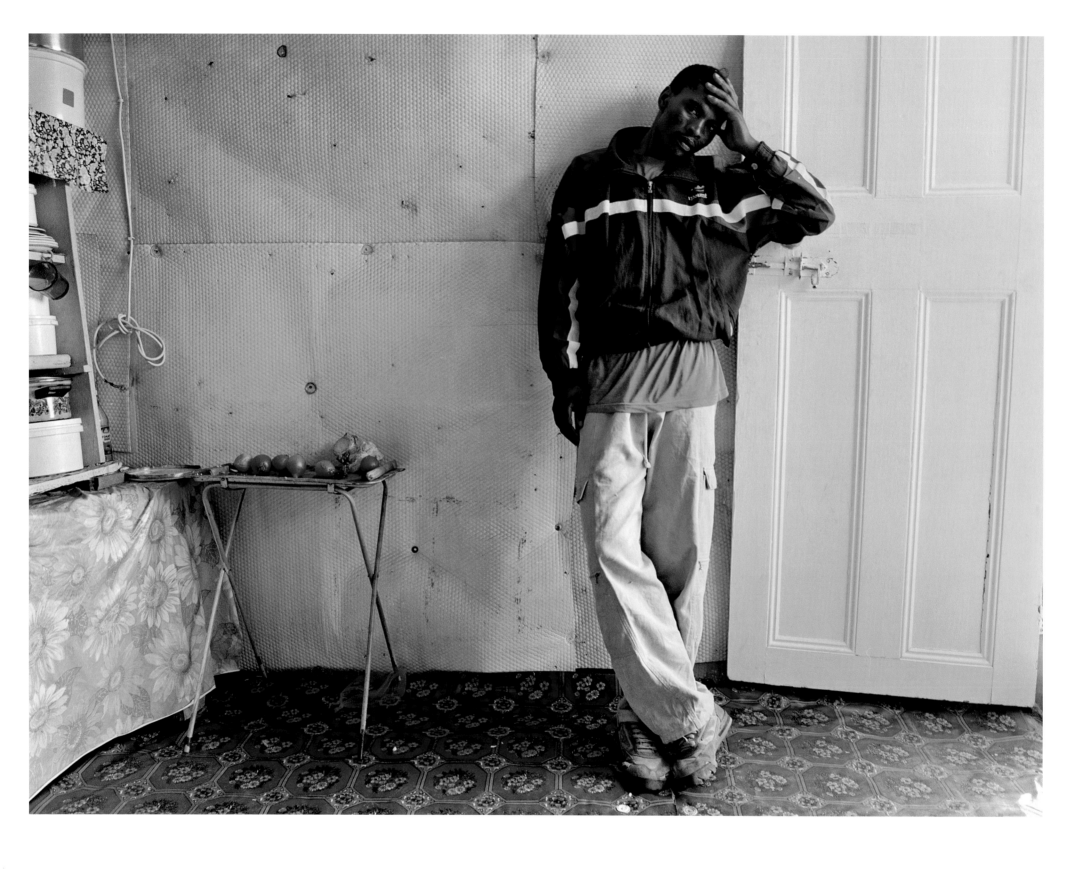

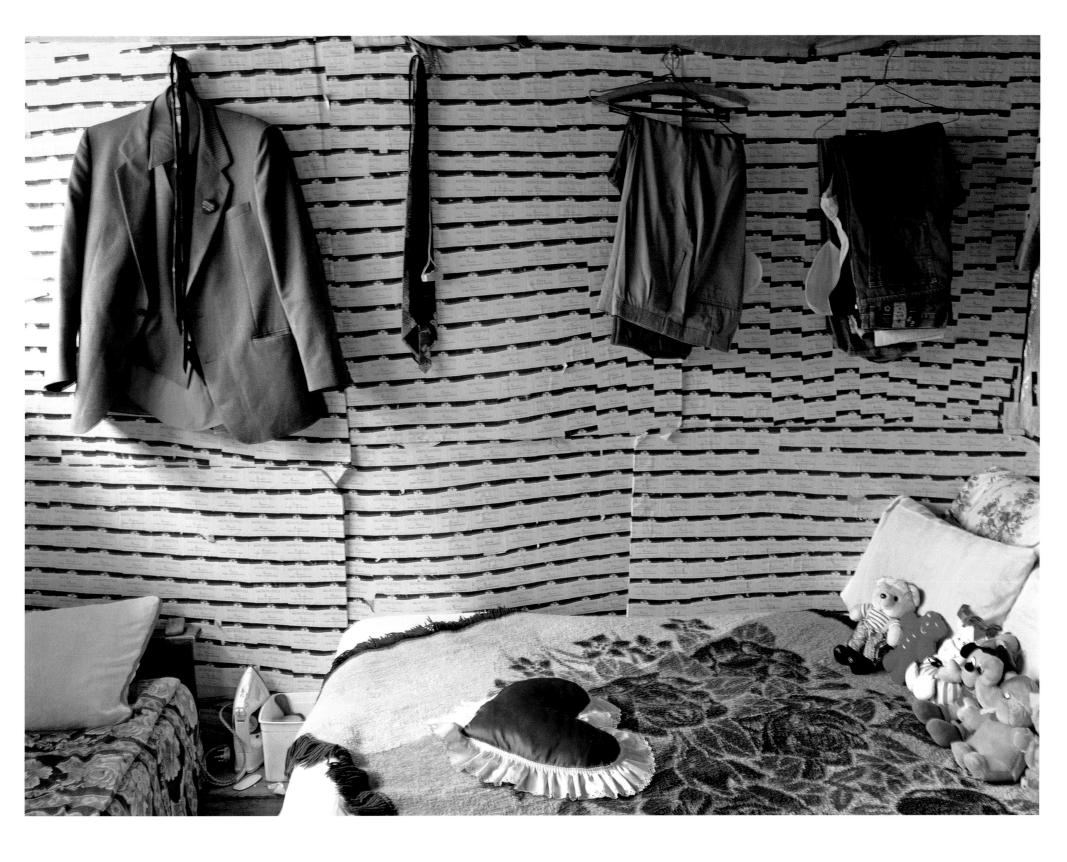

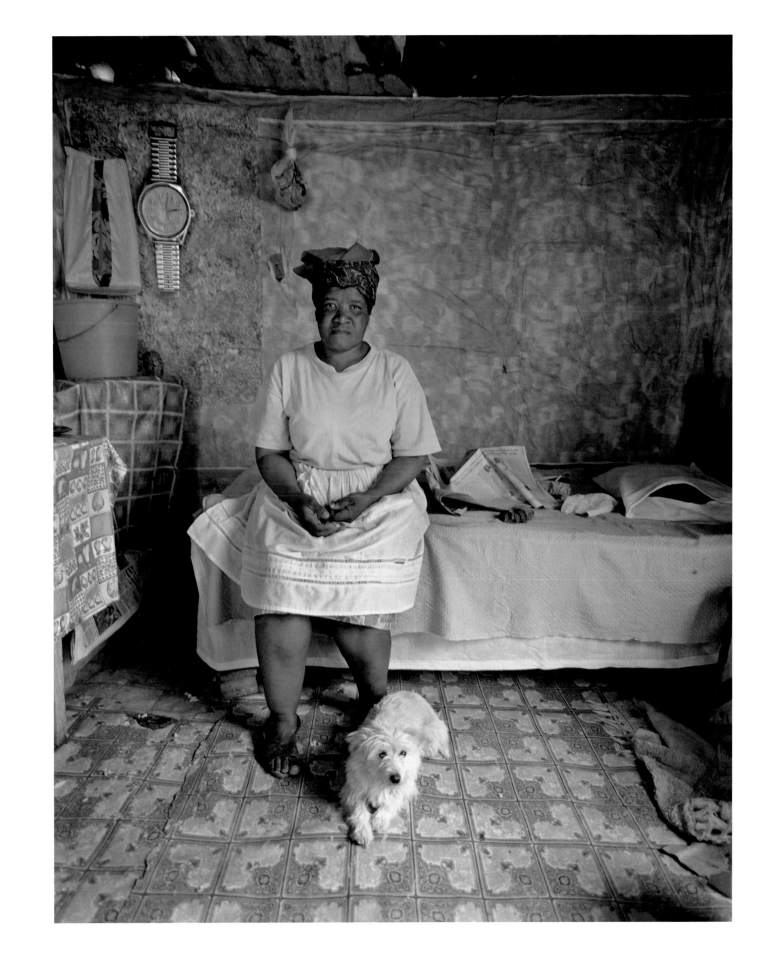

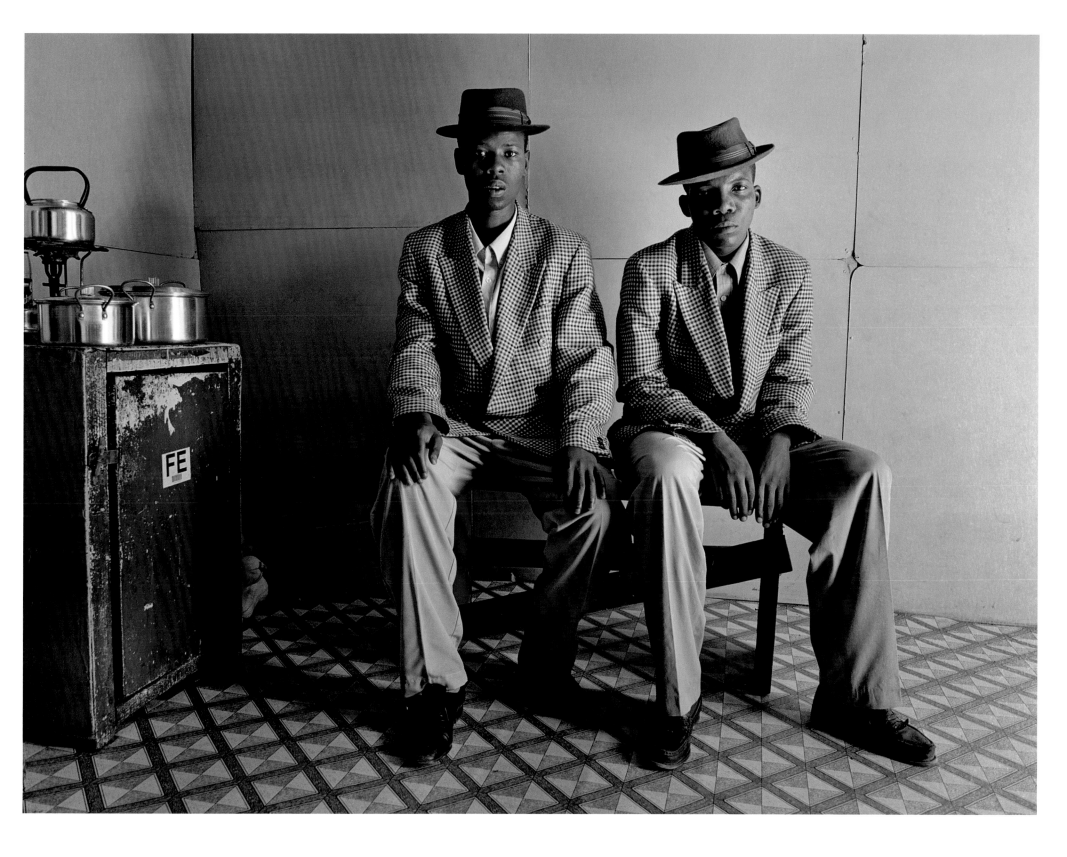

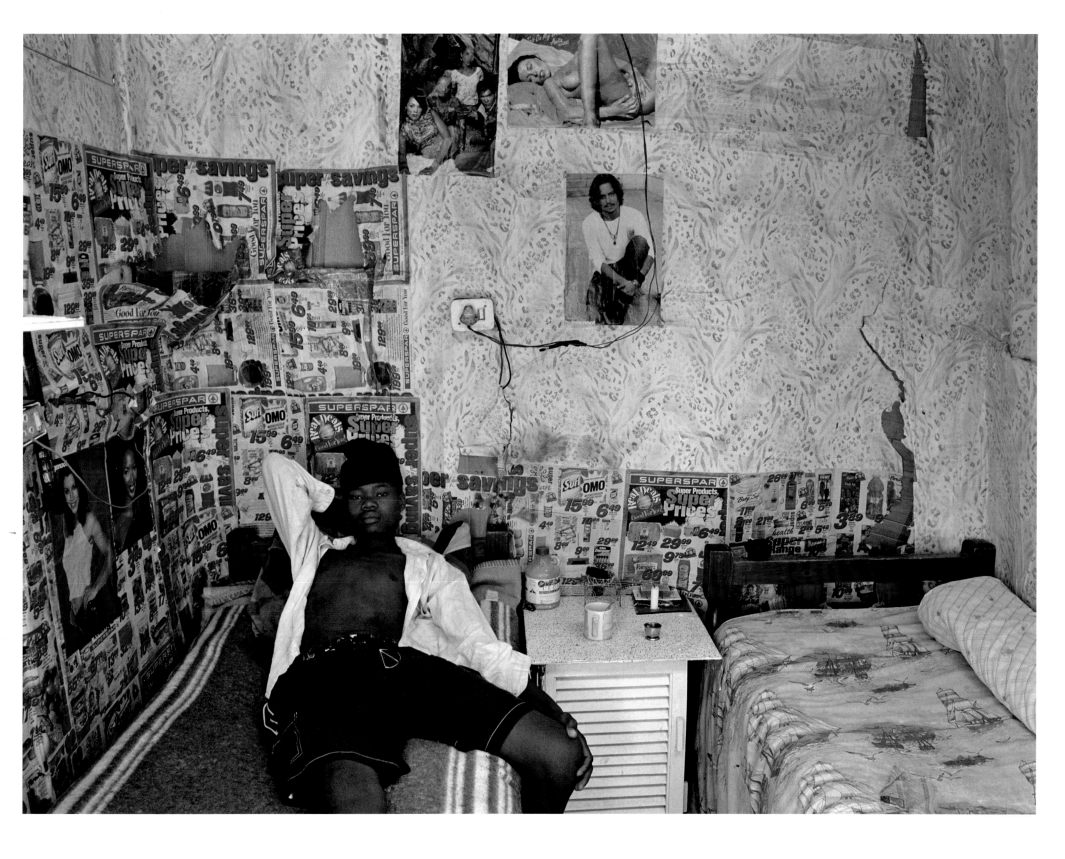

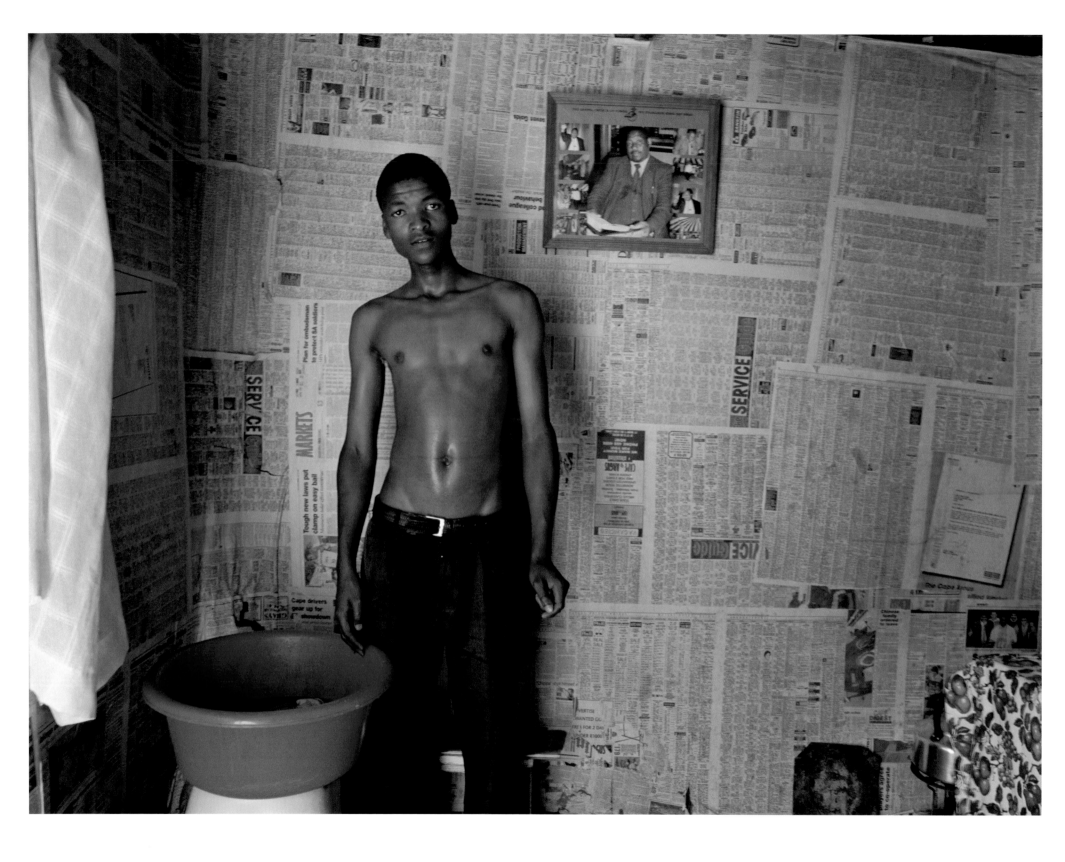

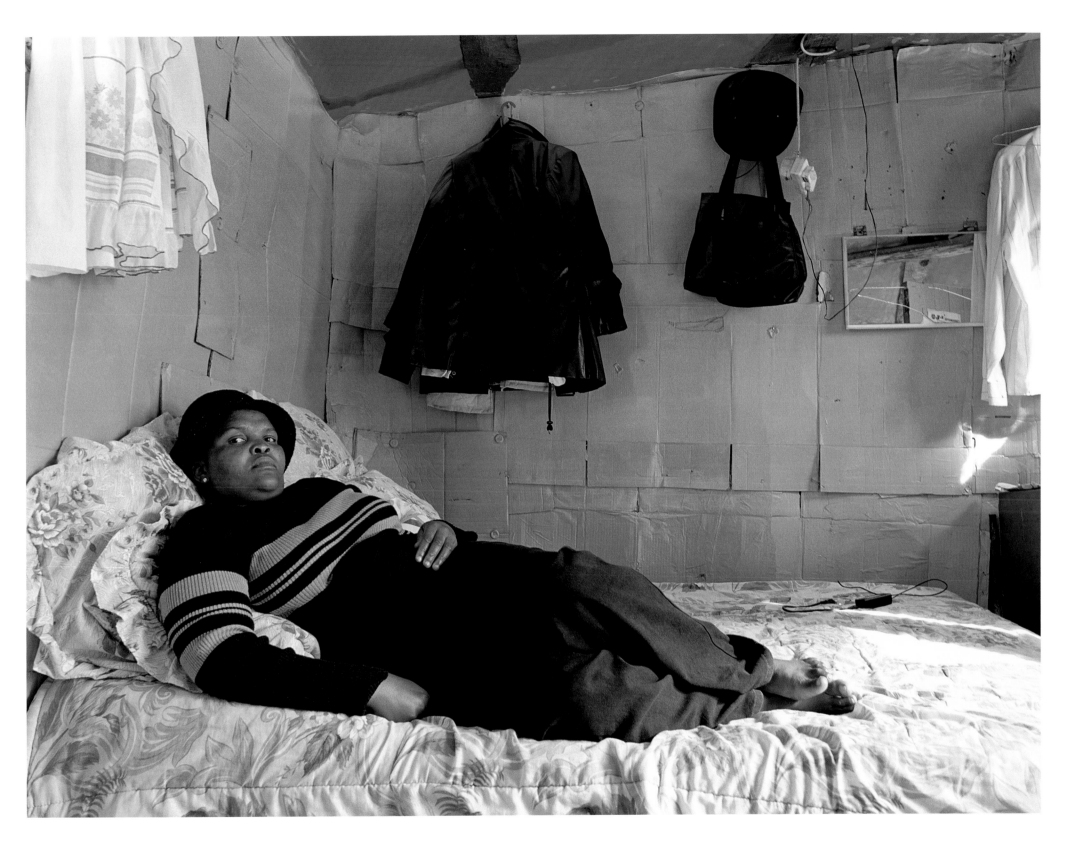

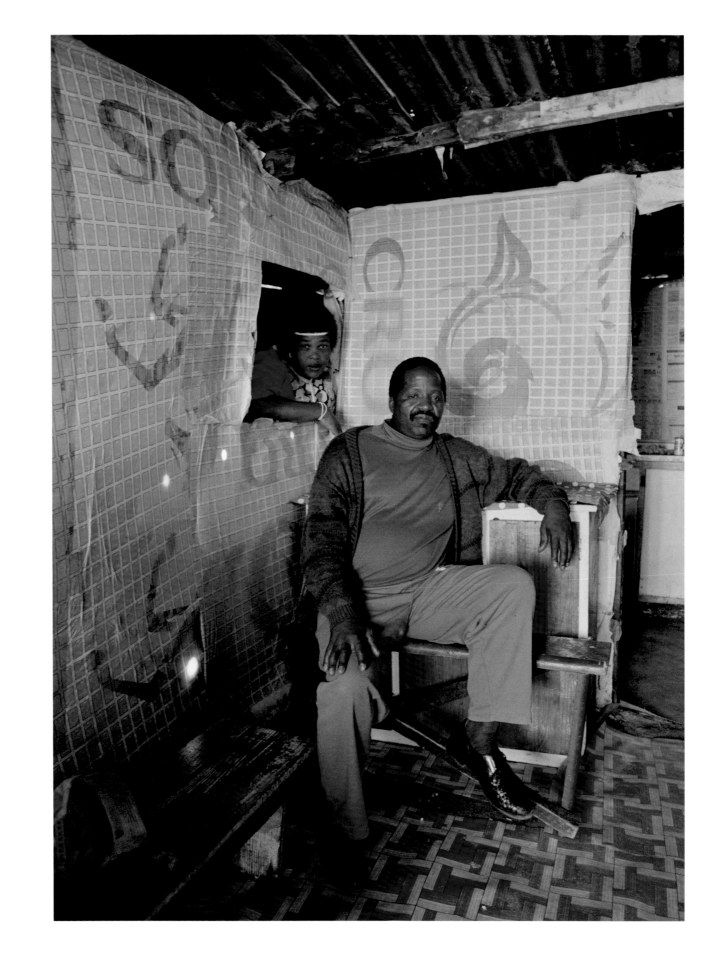

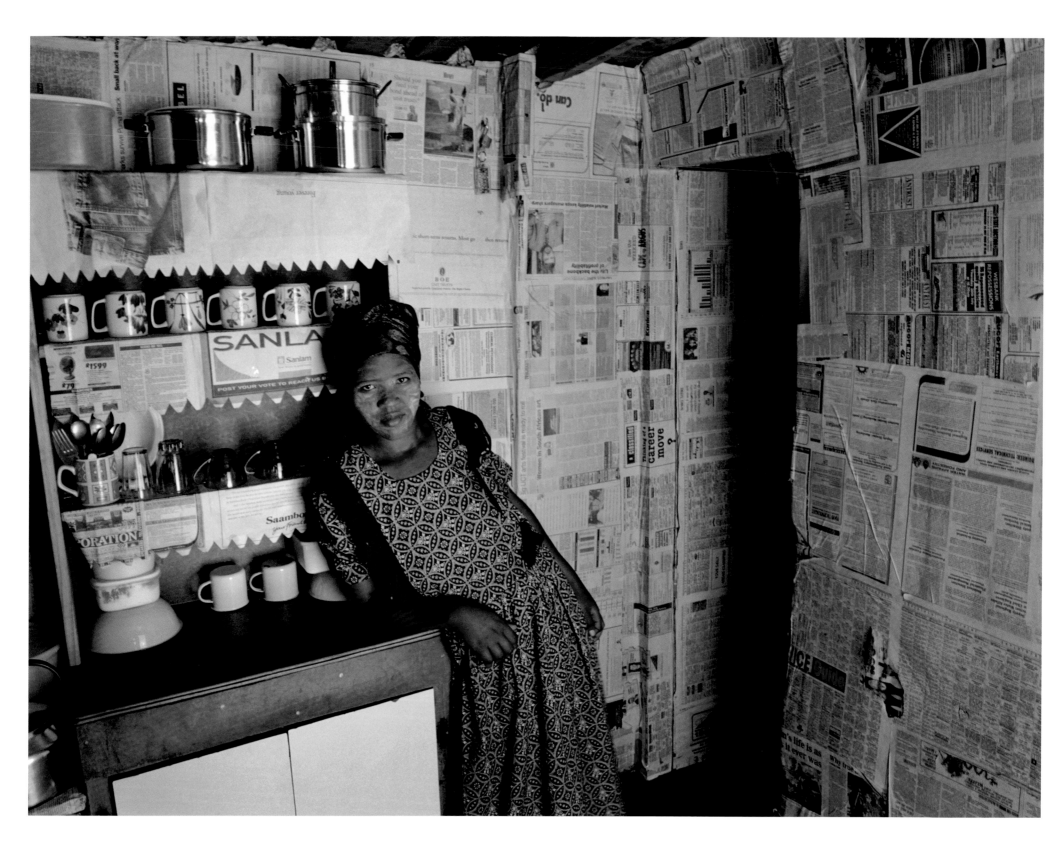

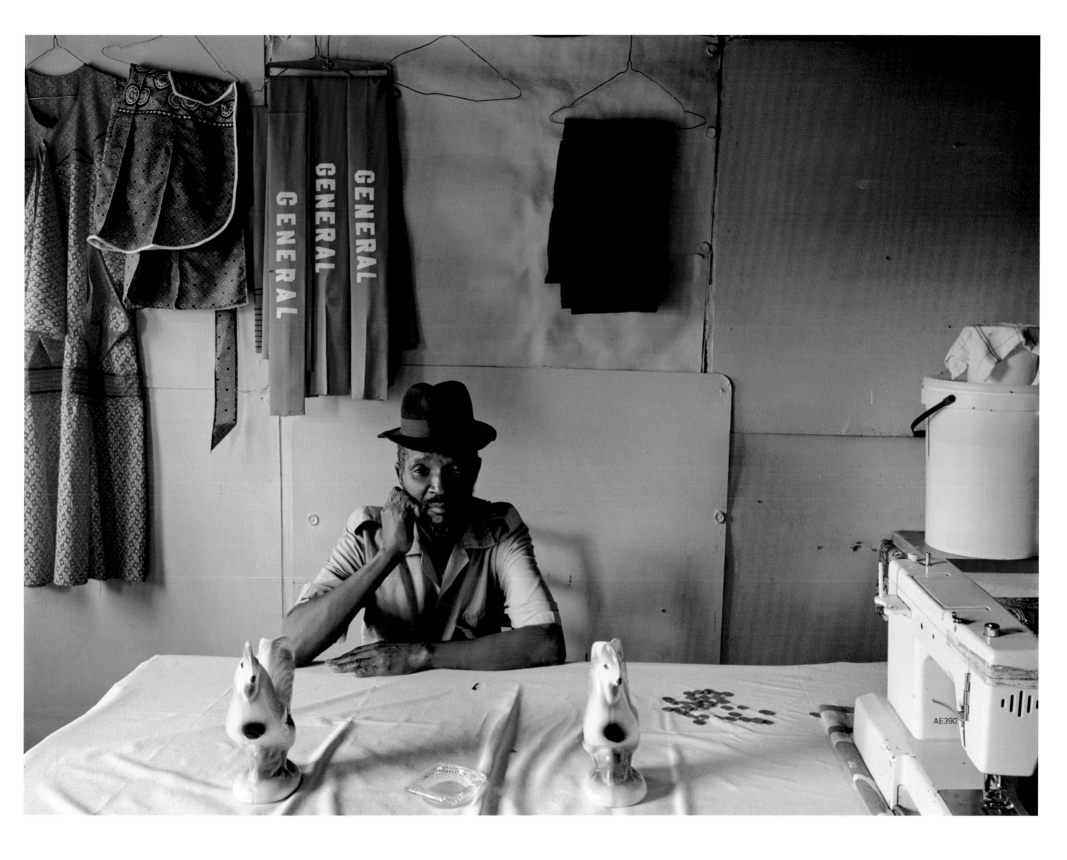

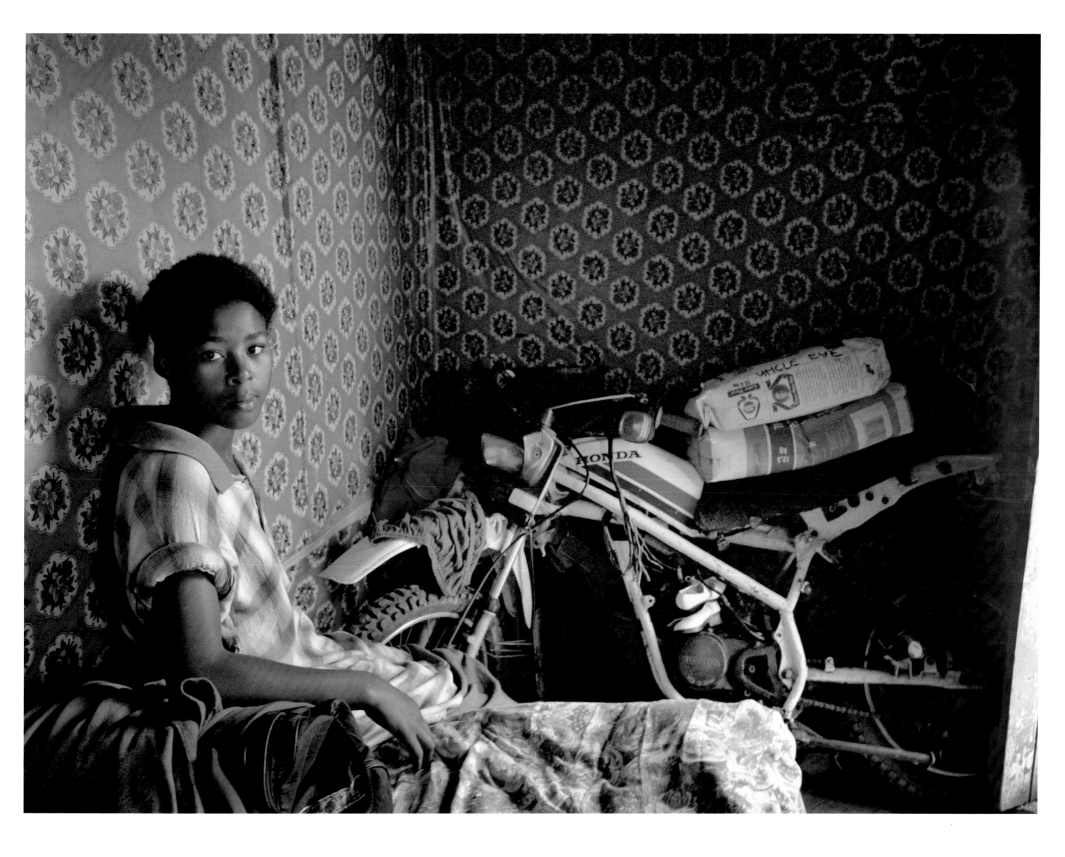

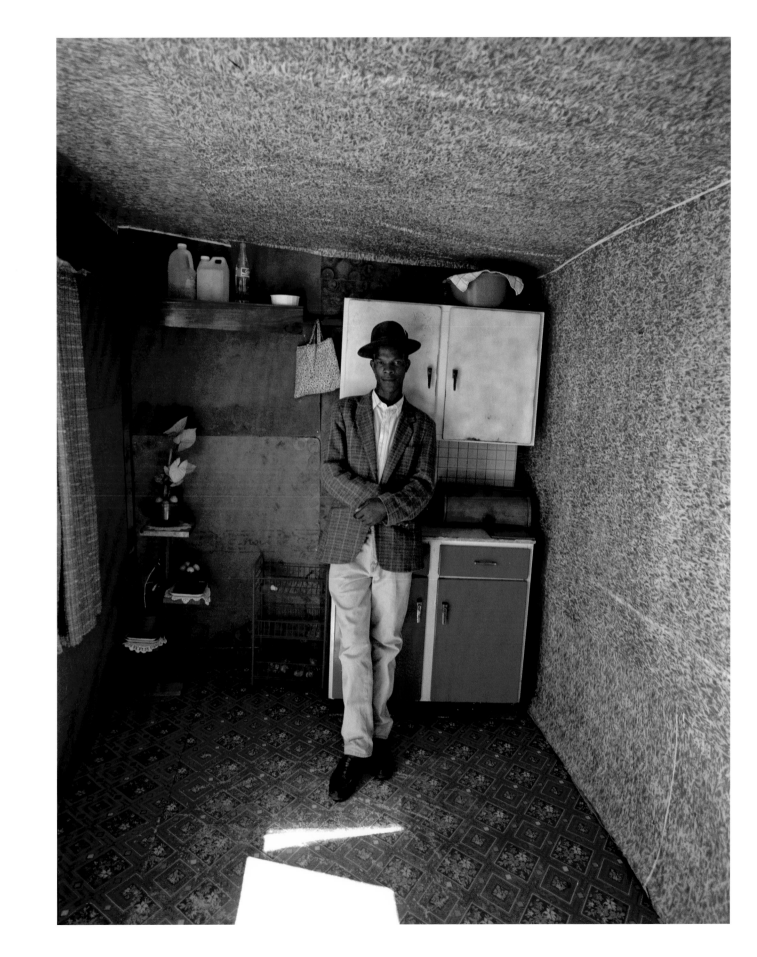

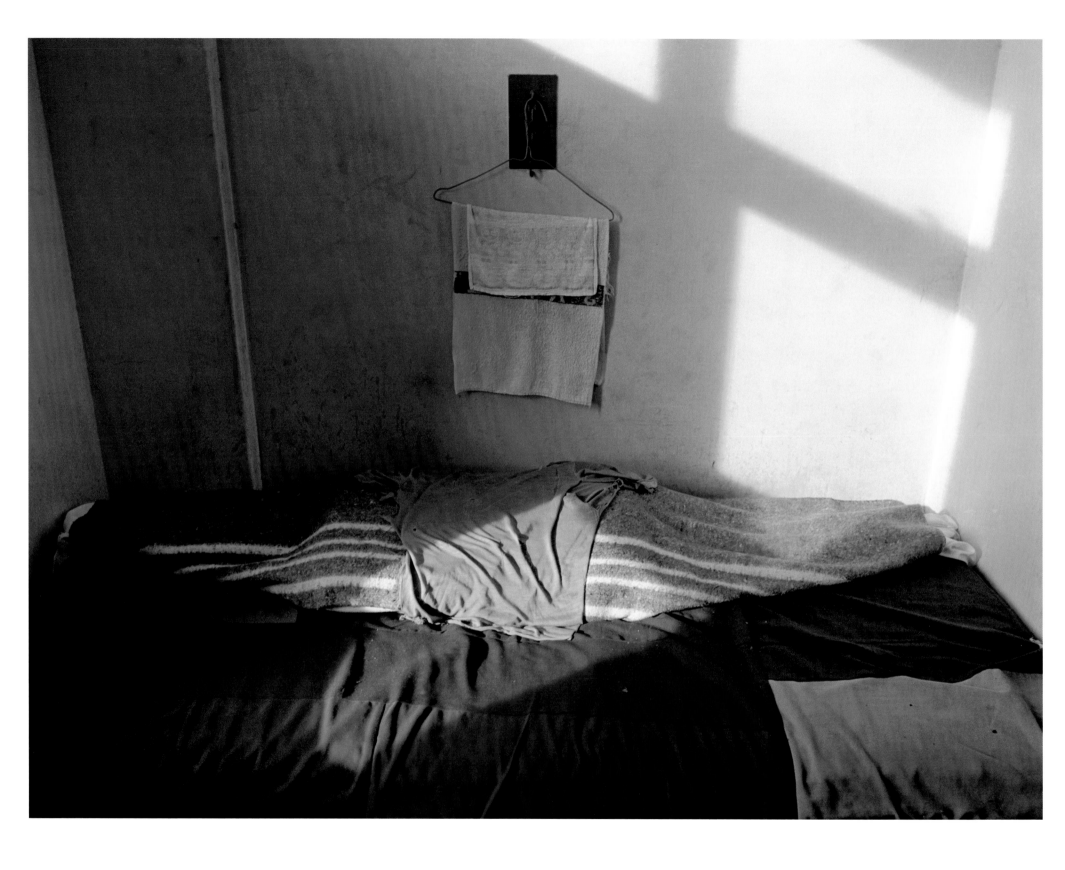

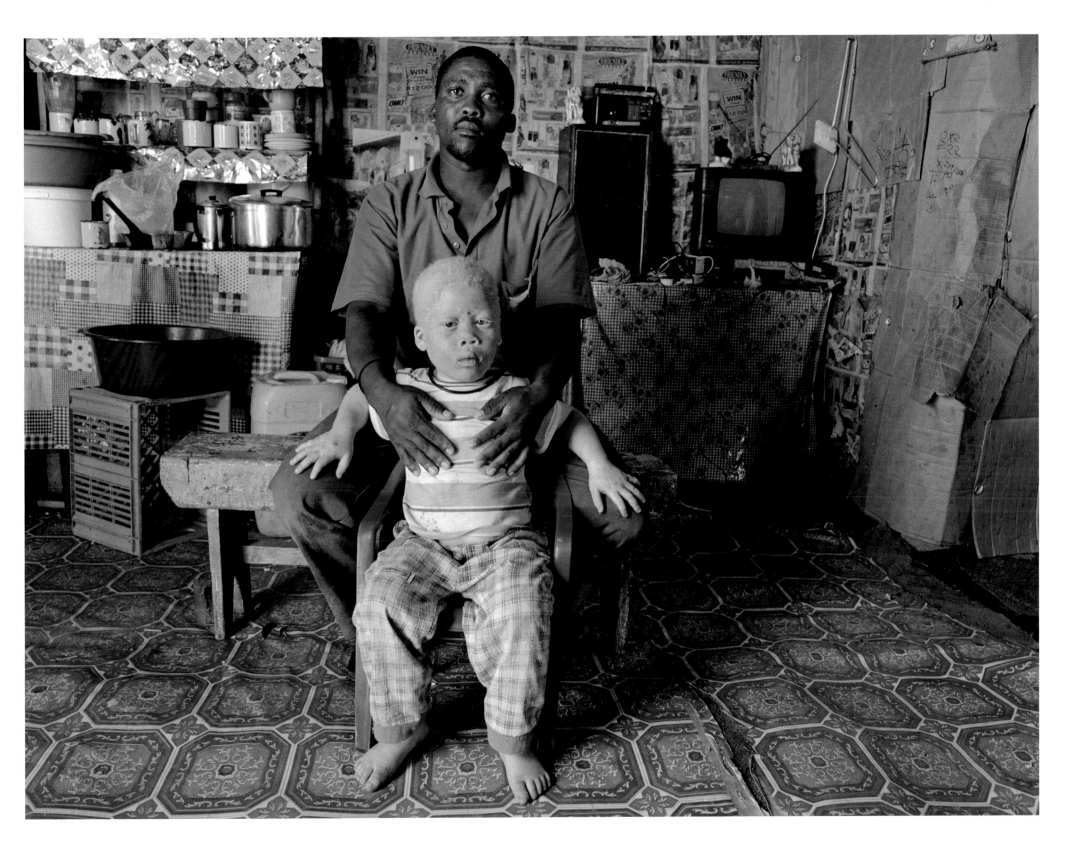

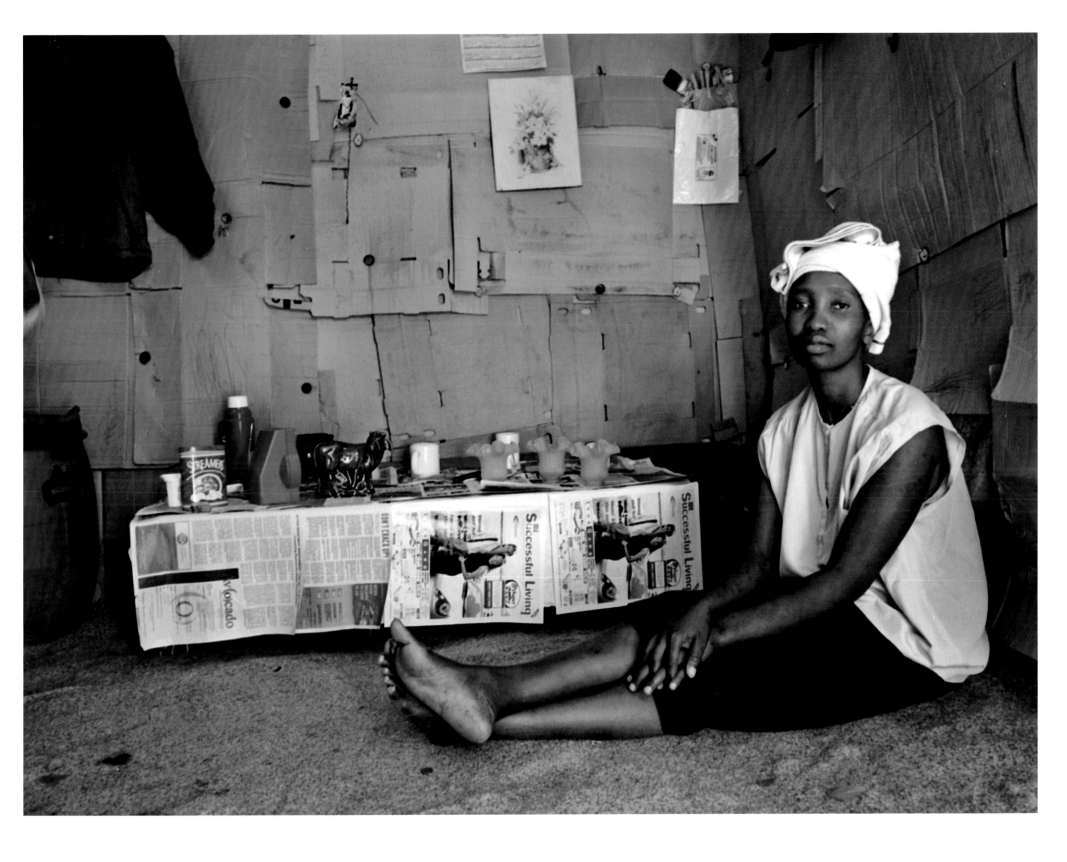

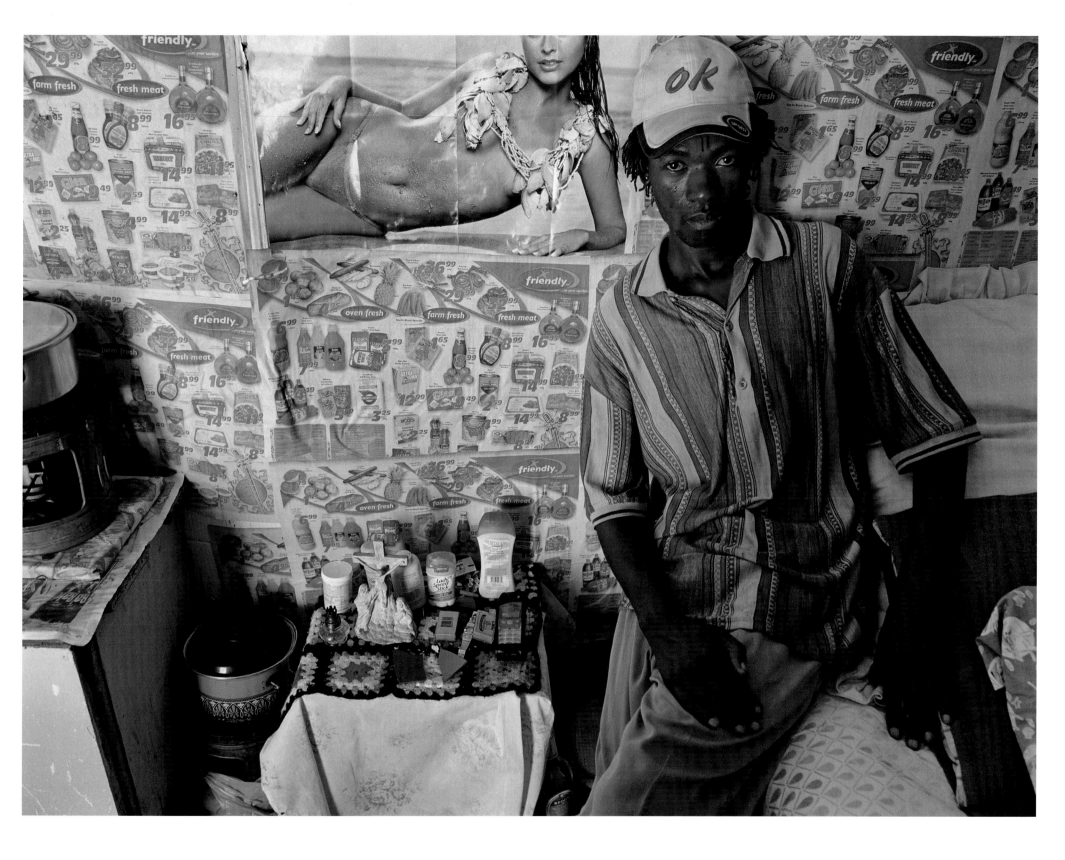

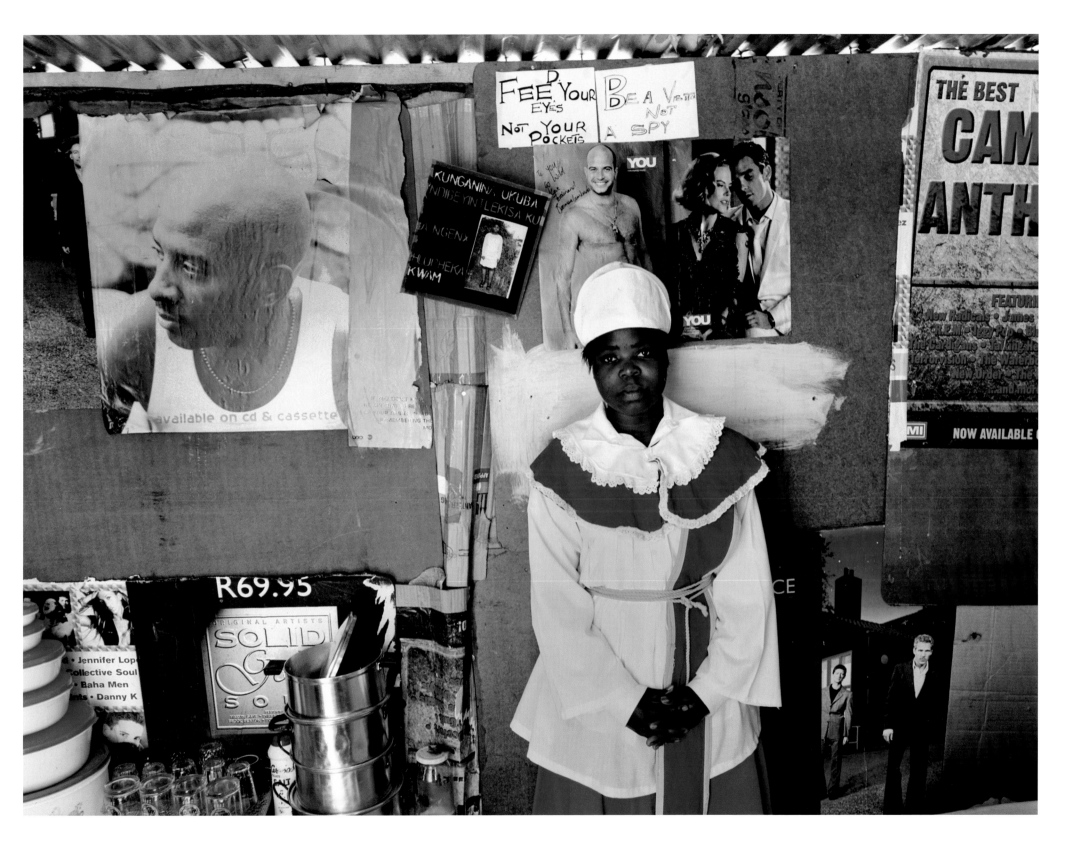

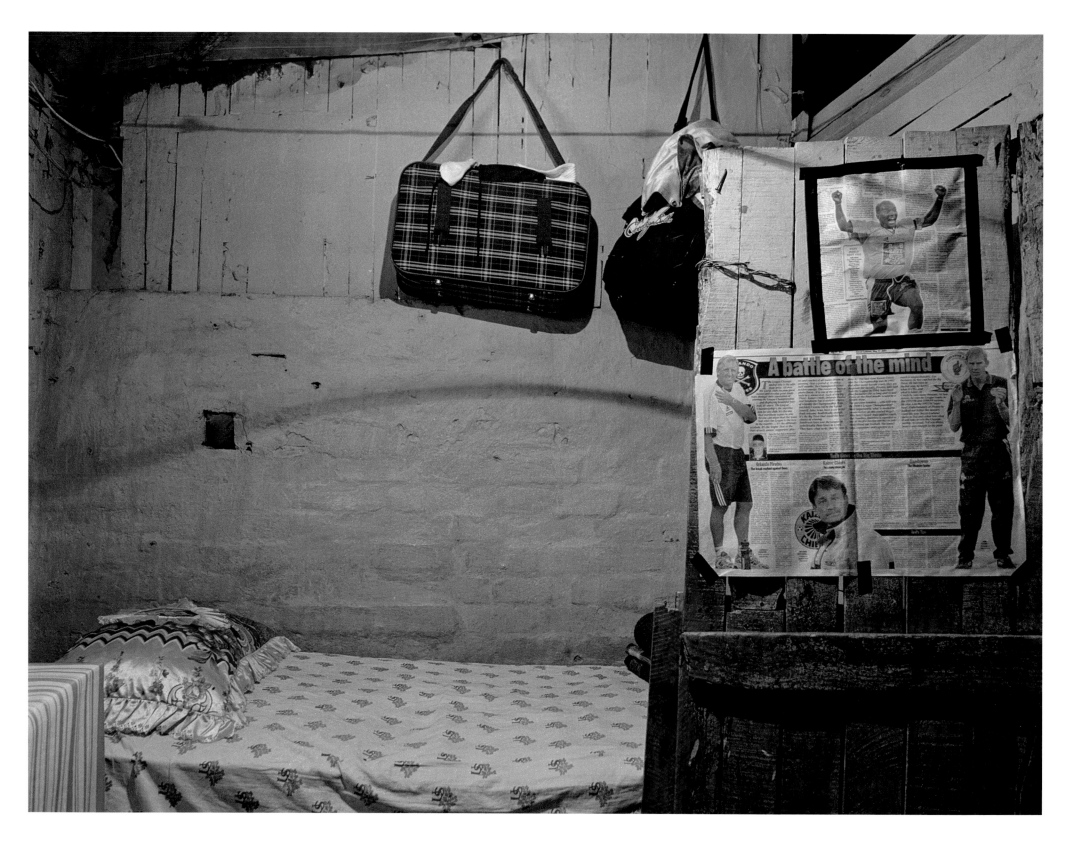

From the series Sugar Cane, 2003

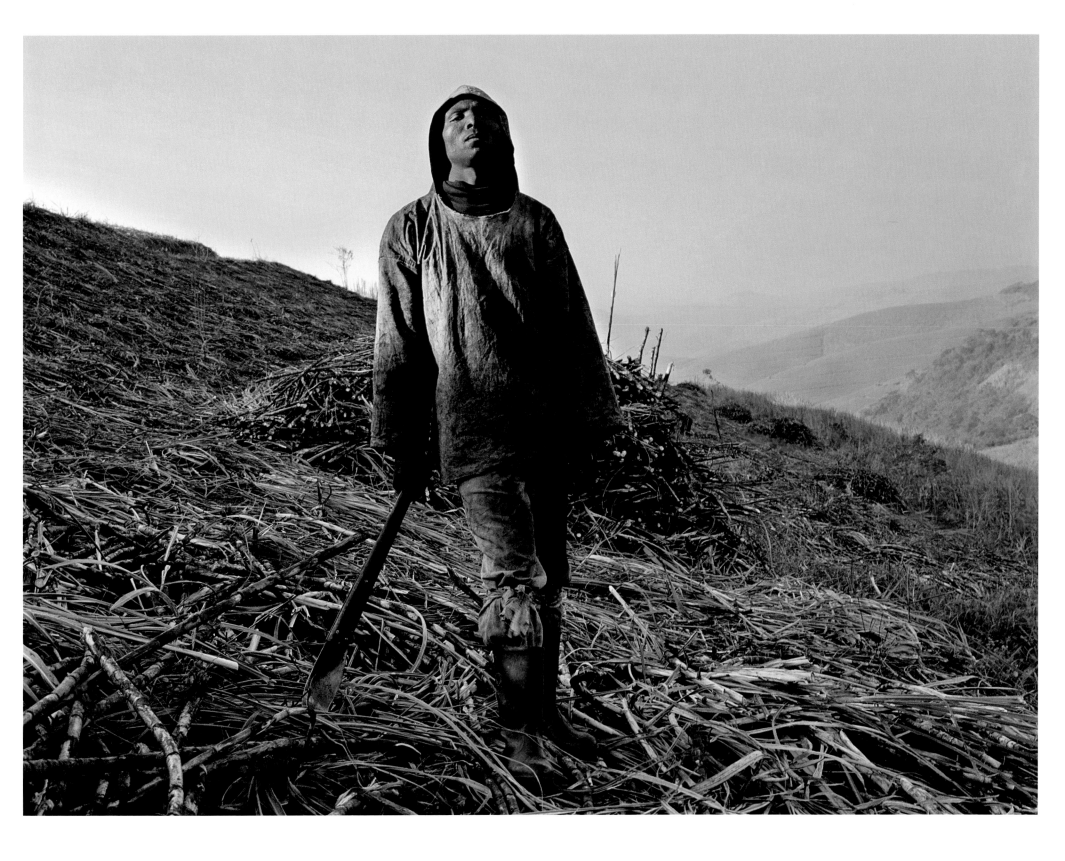

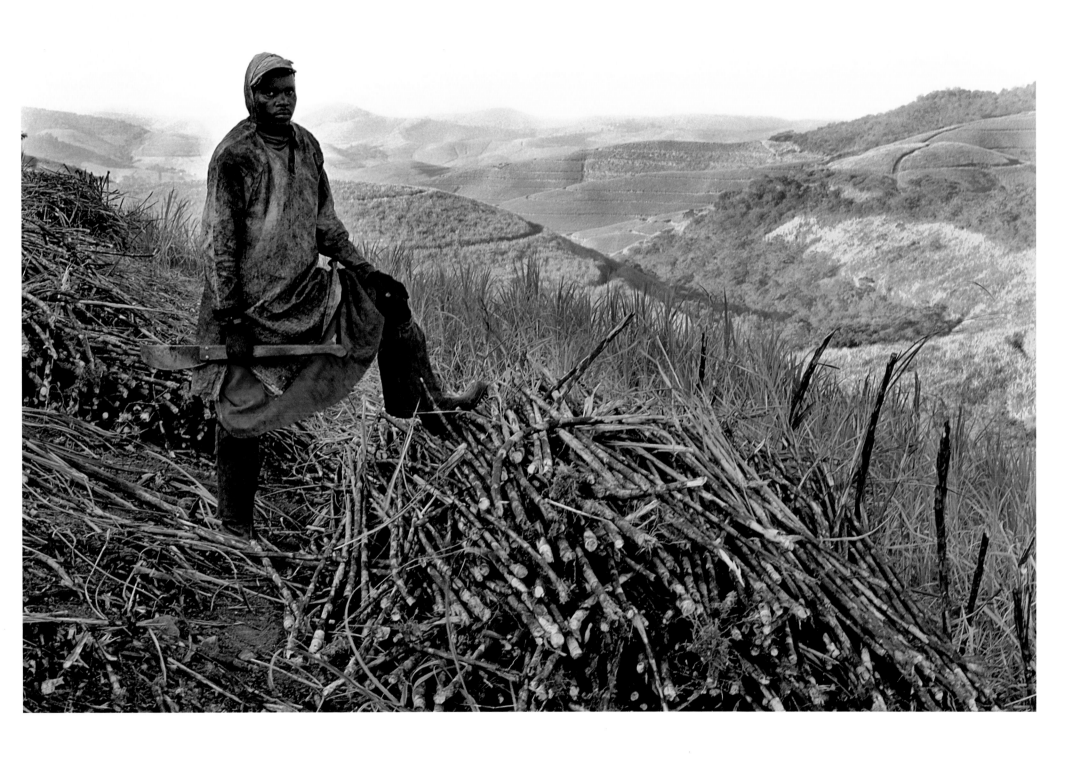

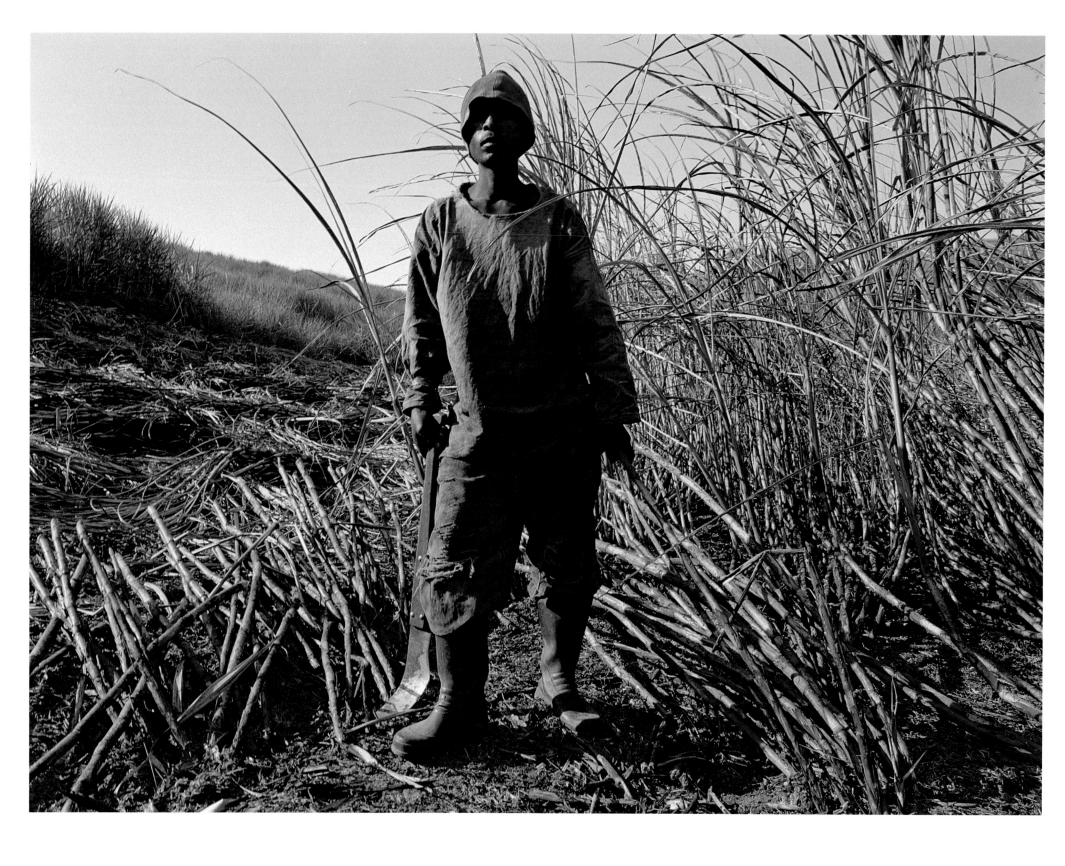

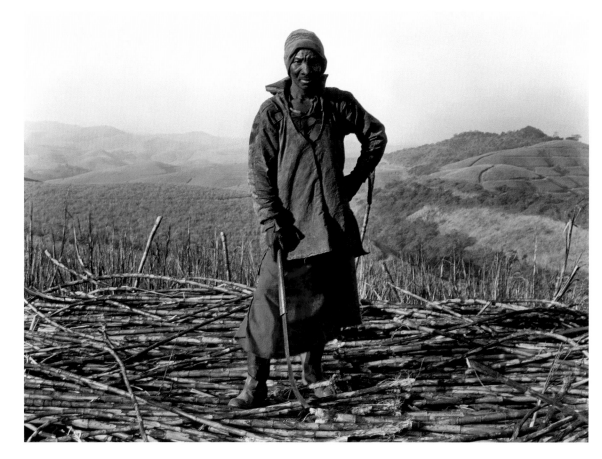

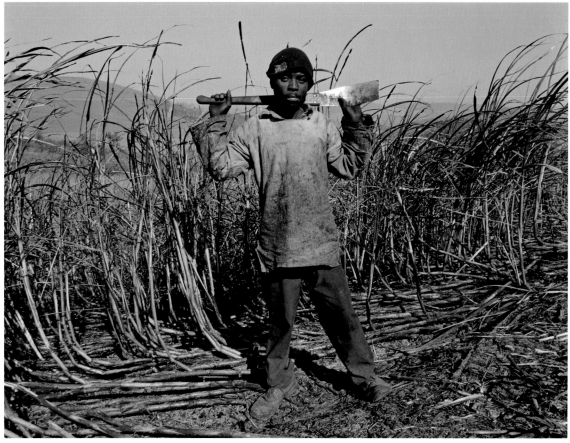

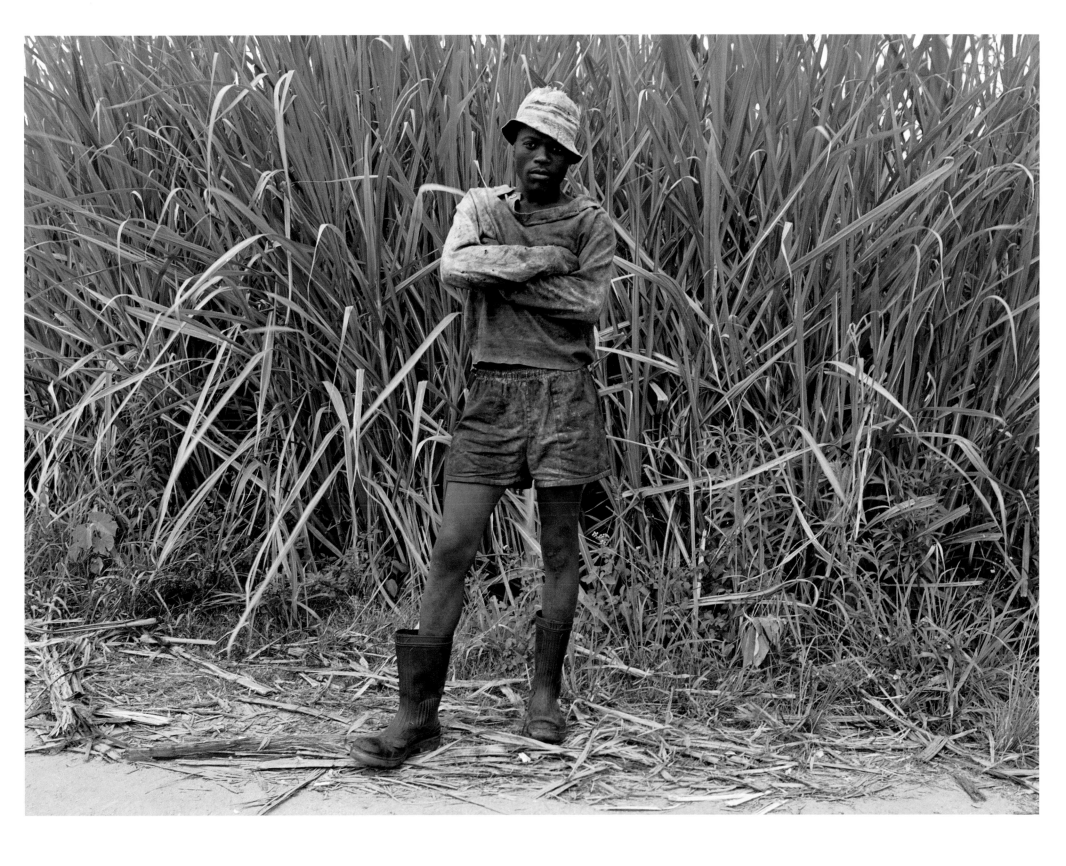

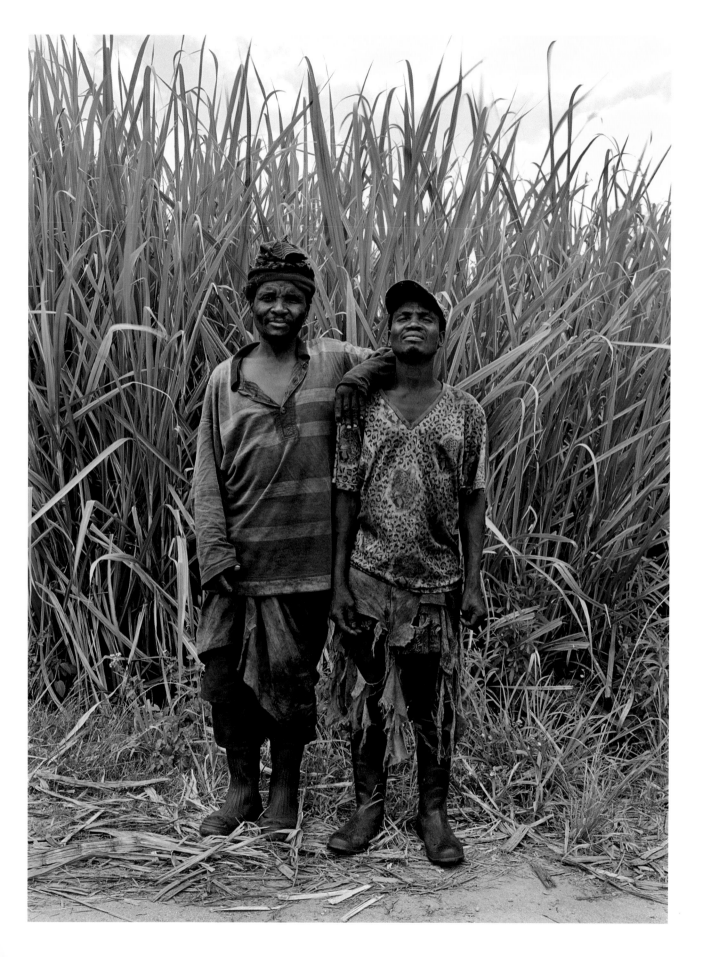

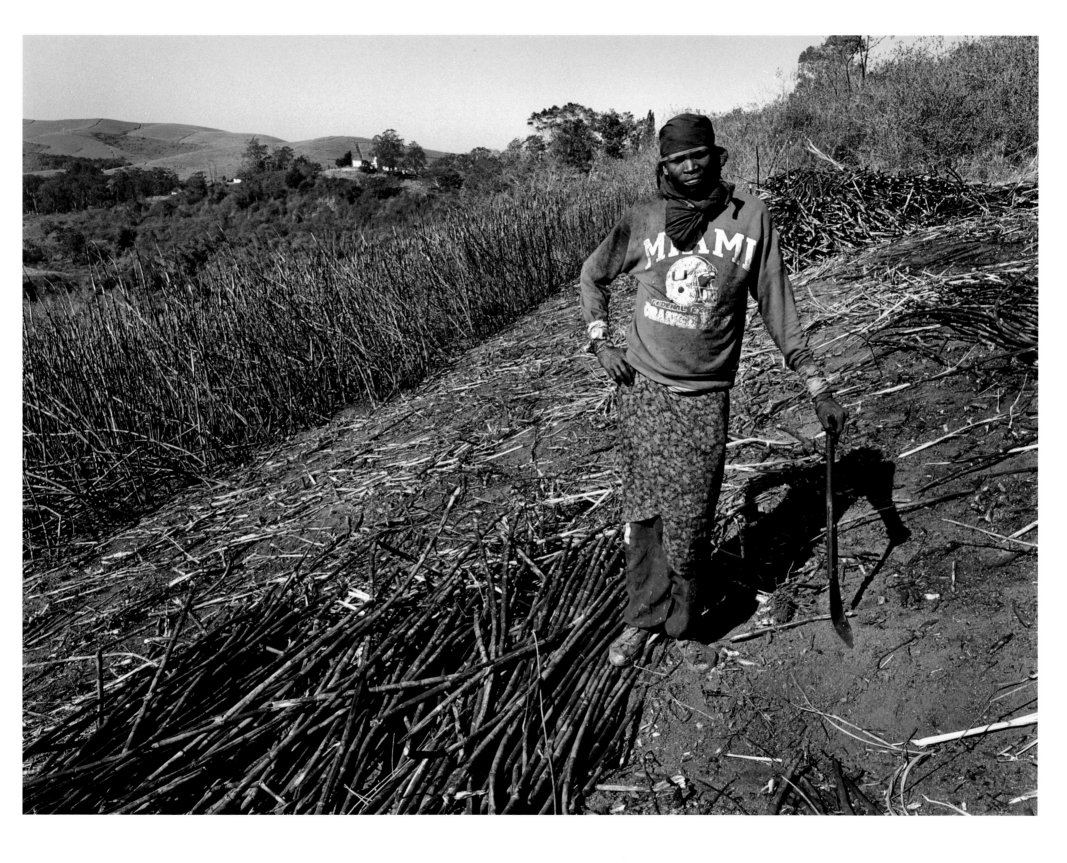

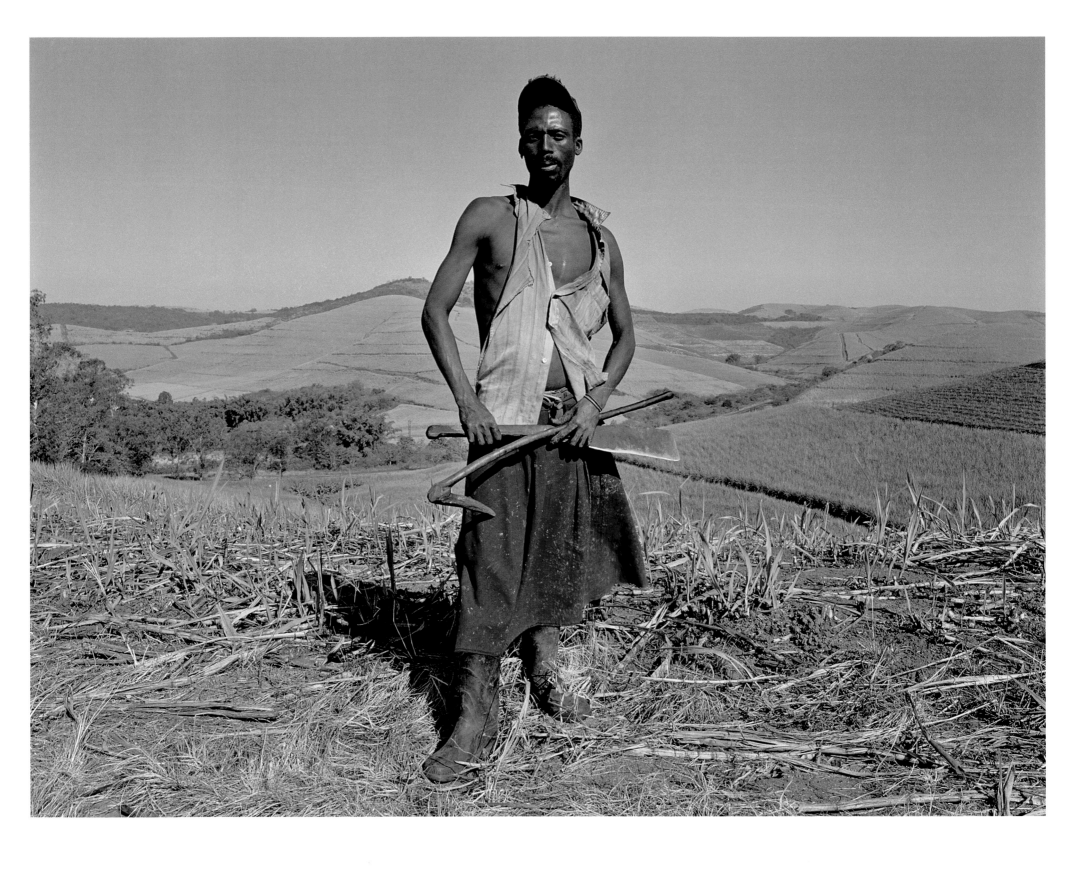

From the series Brick Workers, 2008, and Contemporary Gladiators, 2008

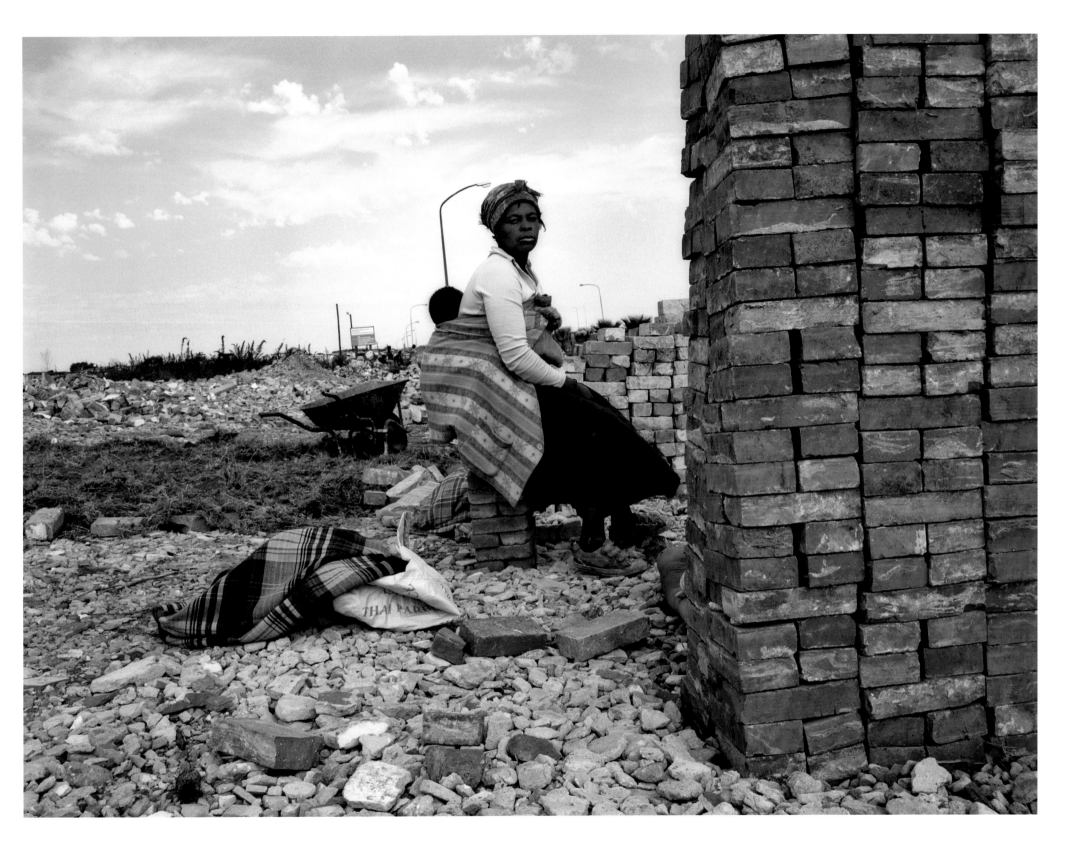

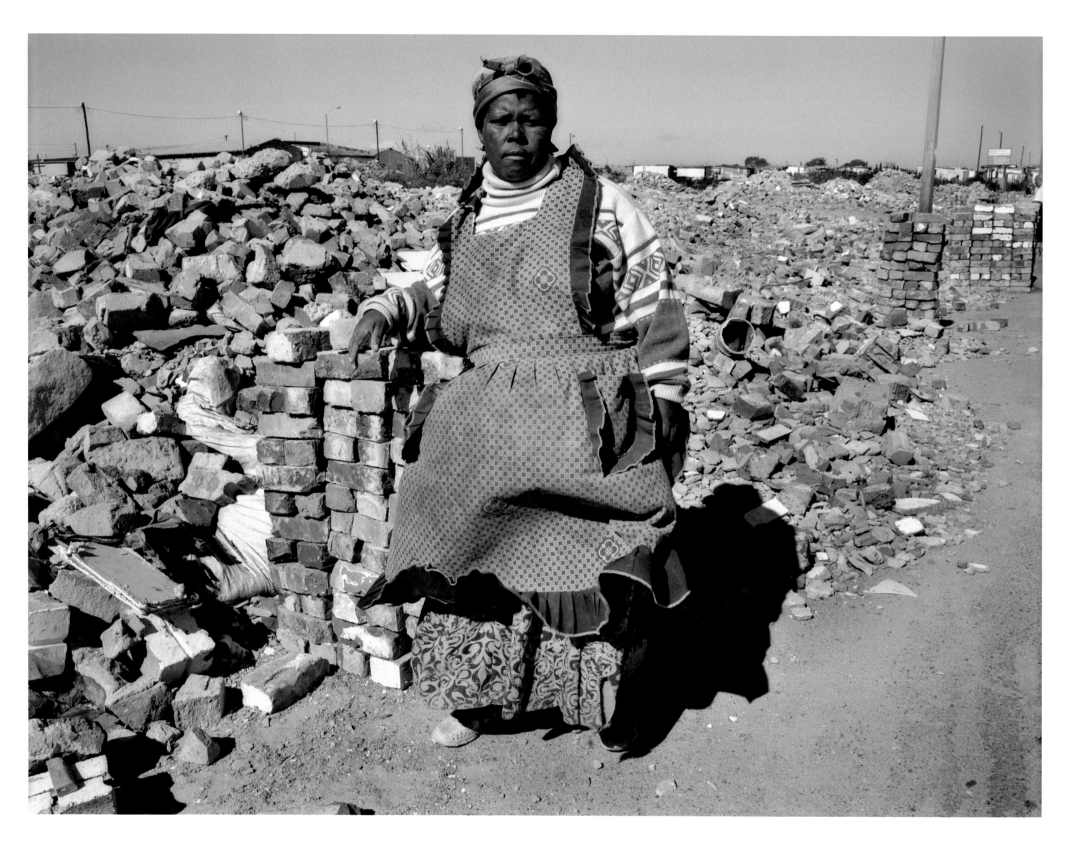

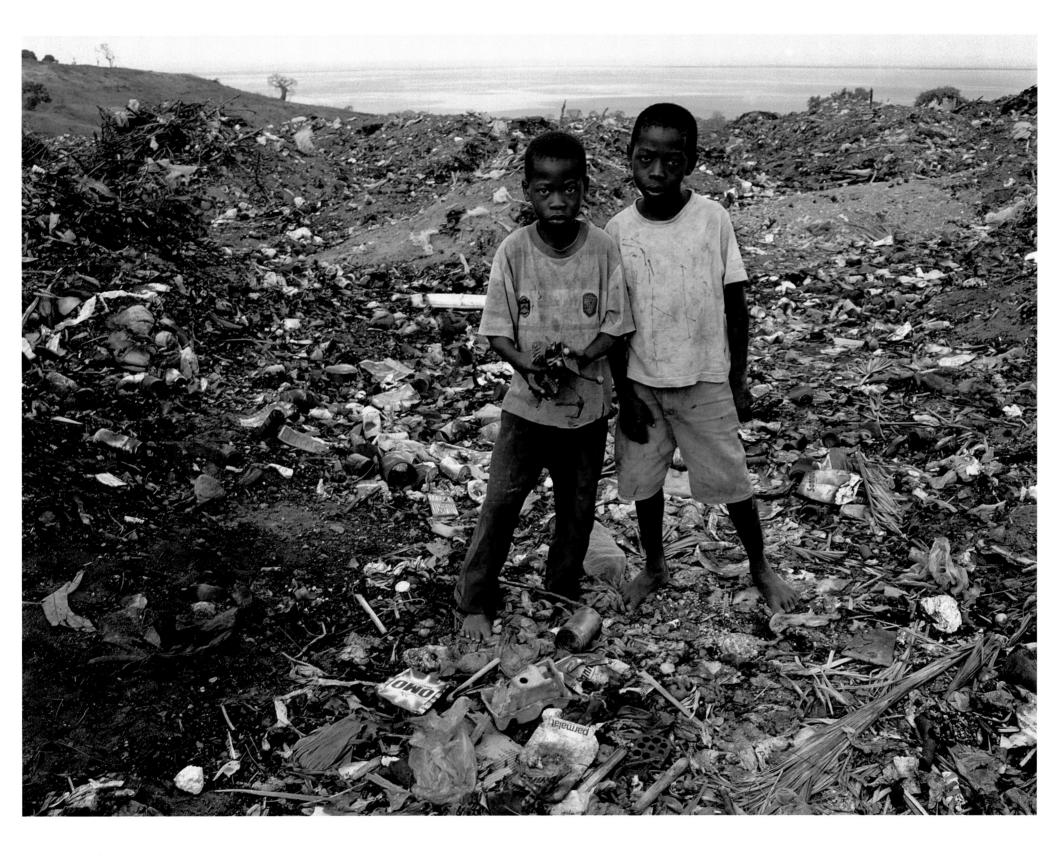

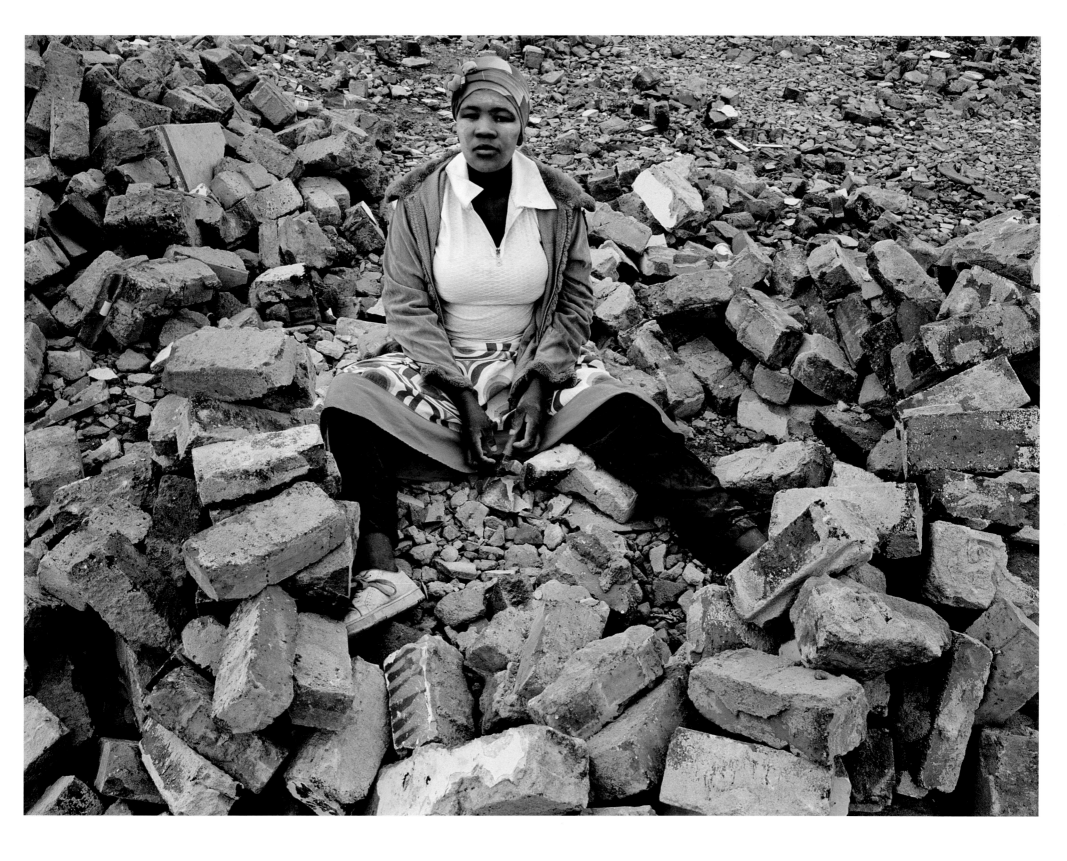

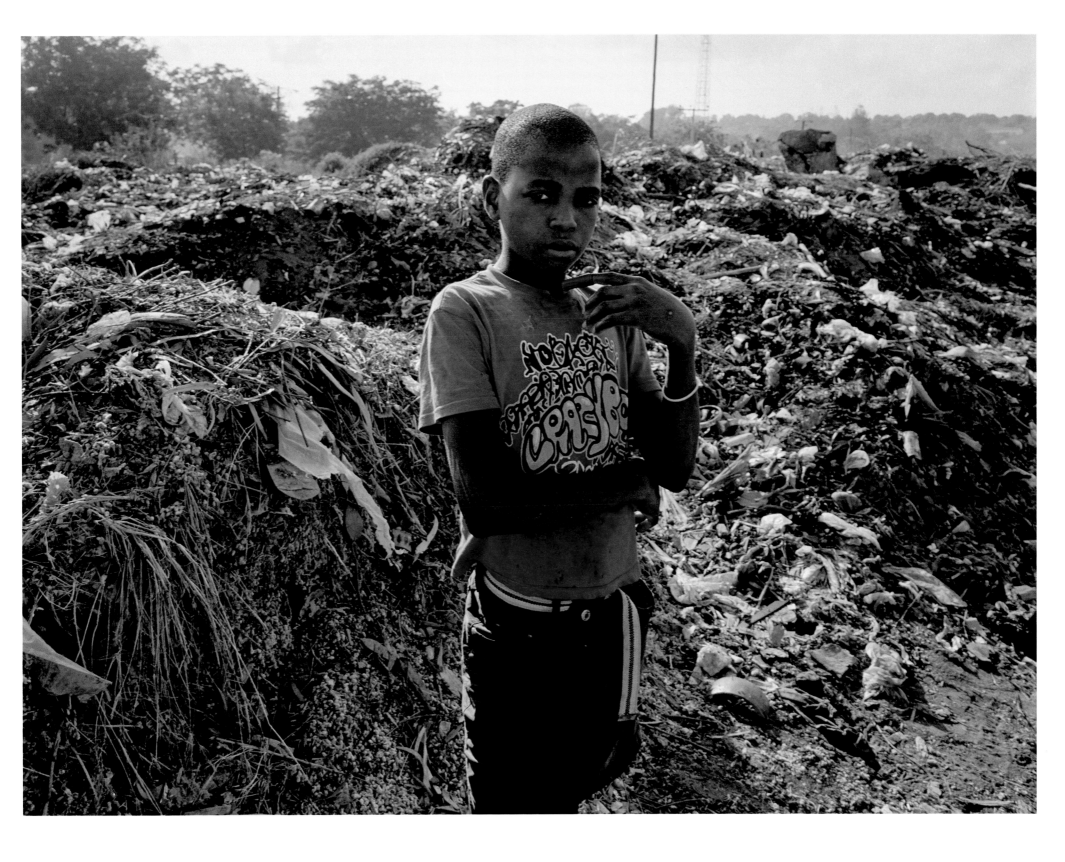

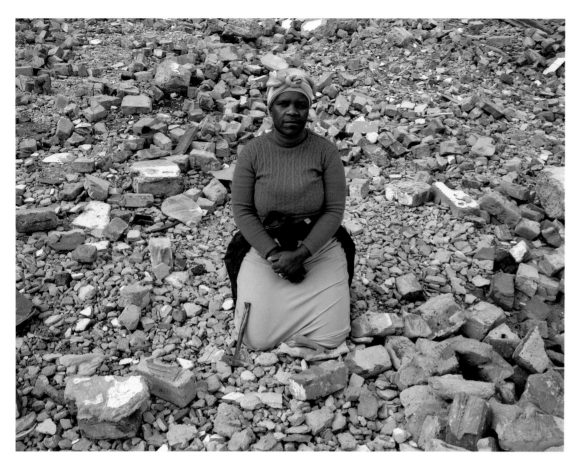

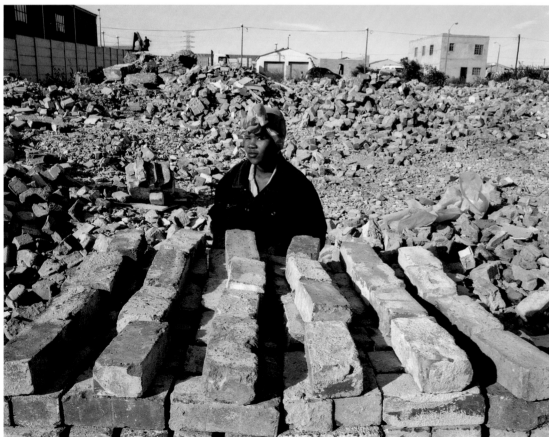

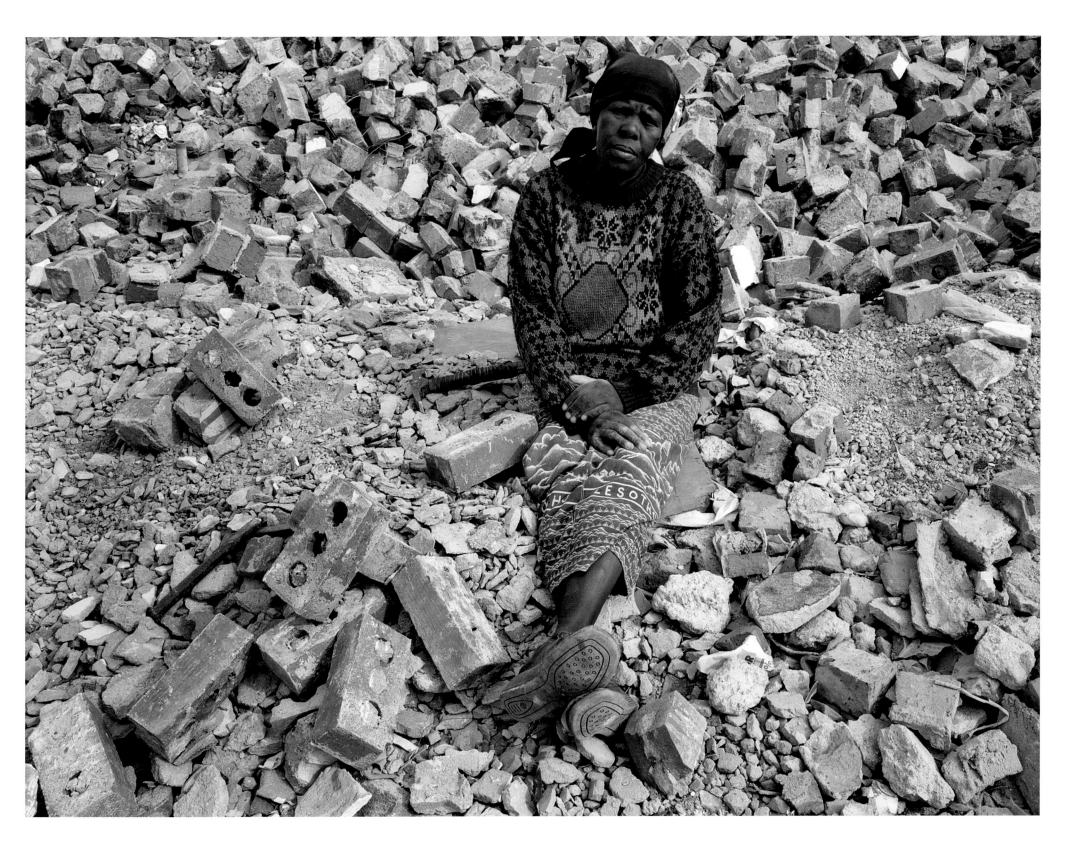

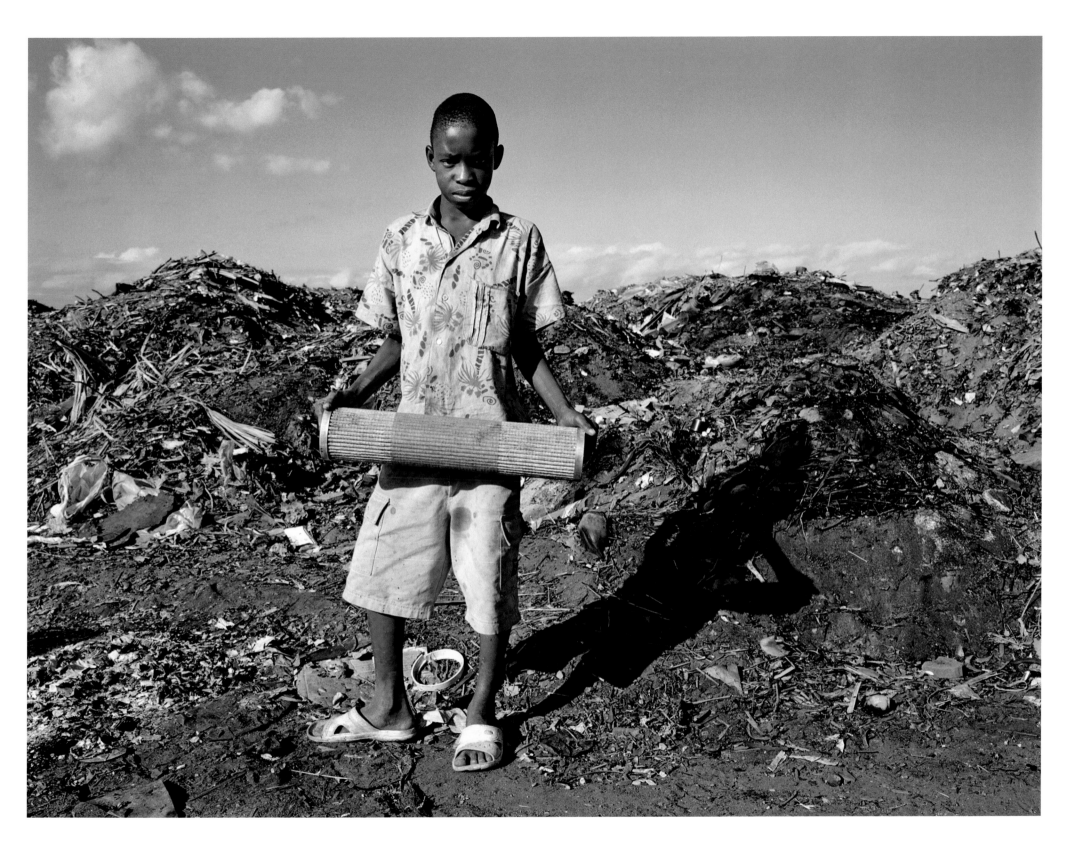

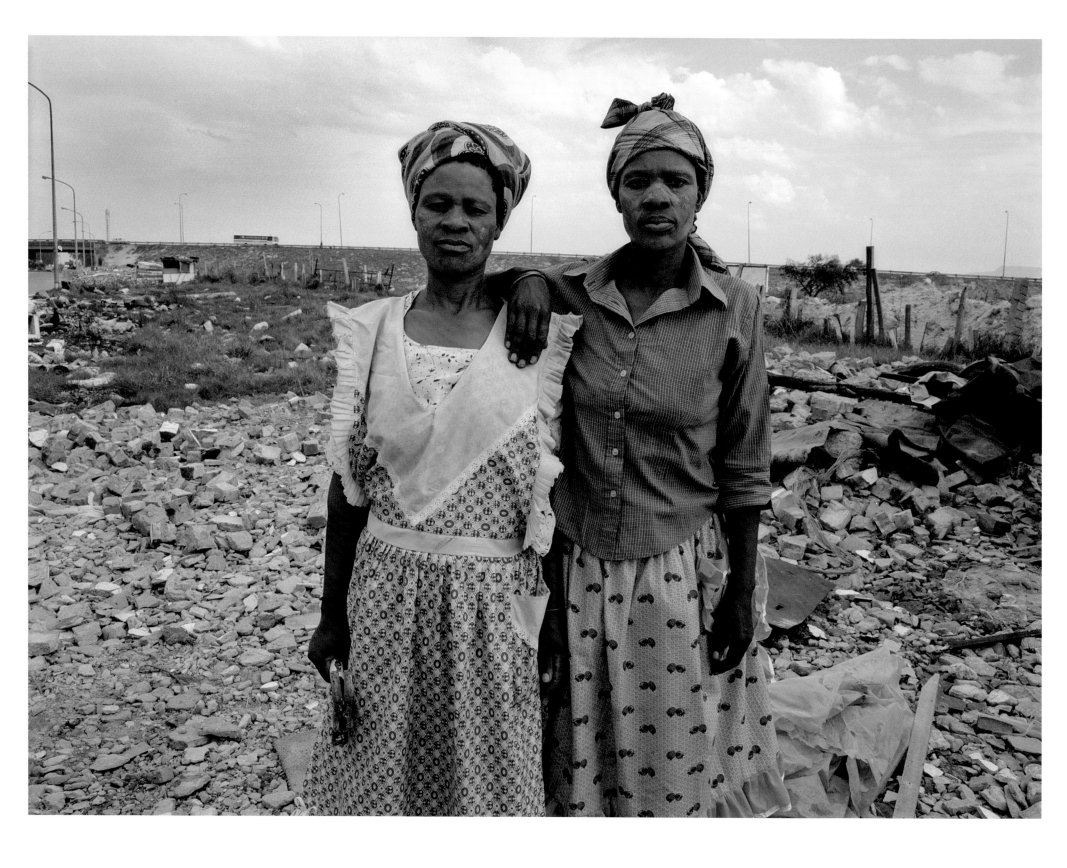

From the series Gold Miners, 2006, and Quartz Miners, 2007–8

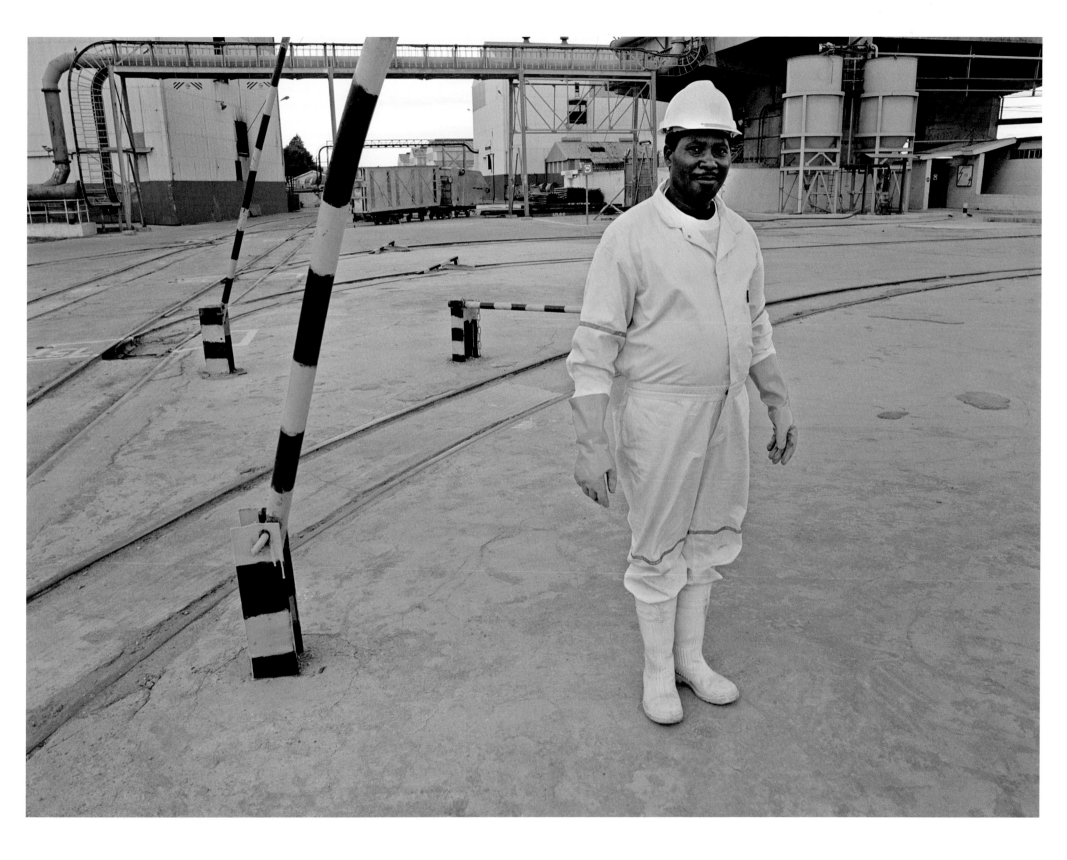

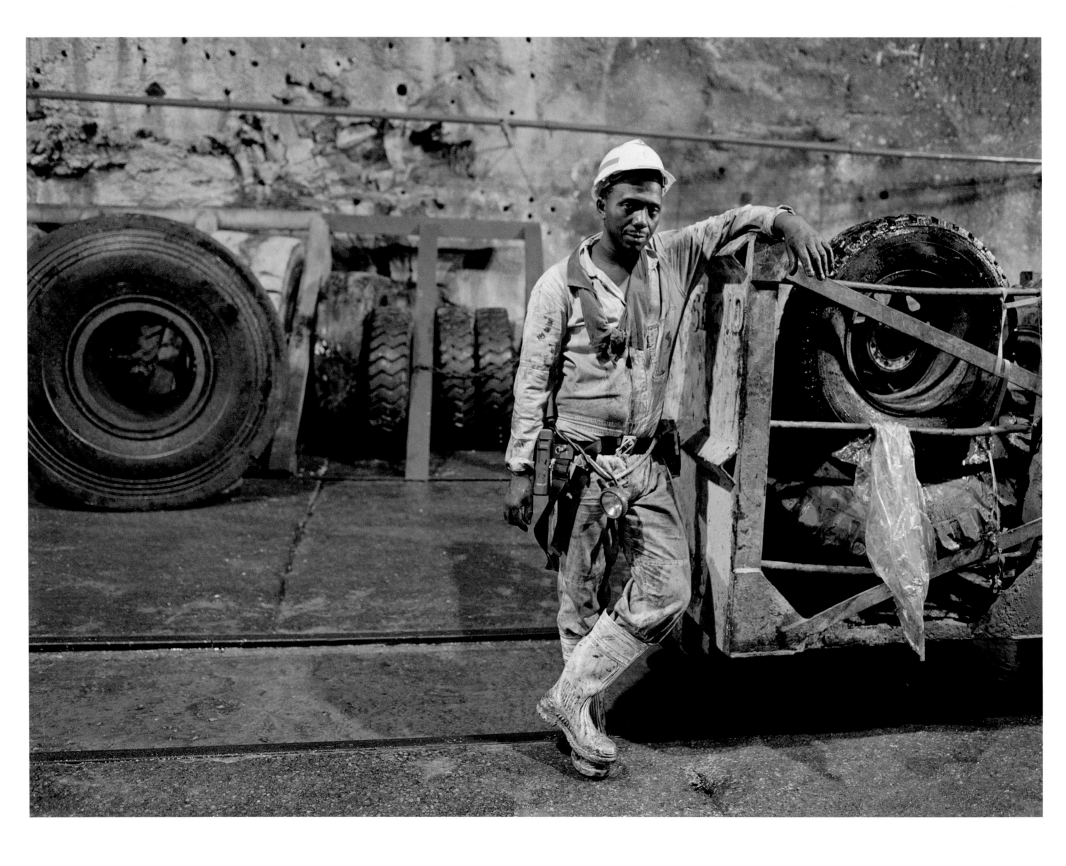

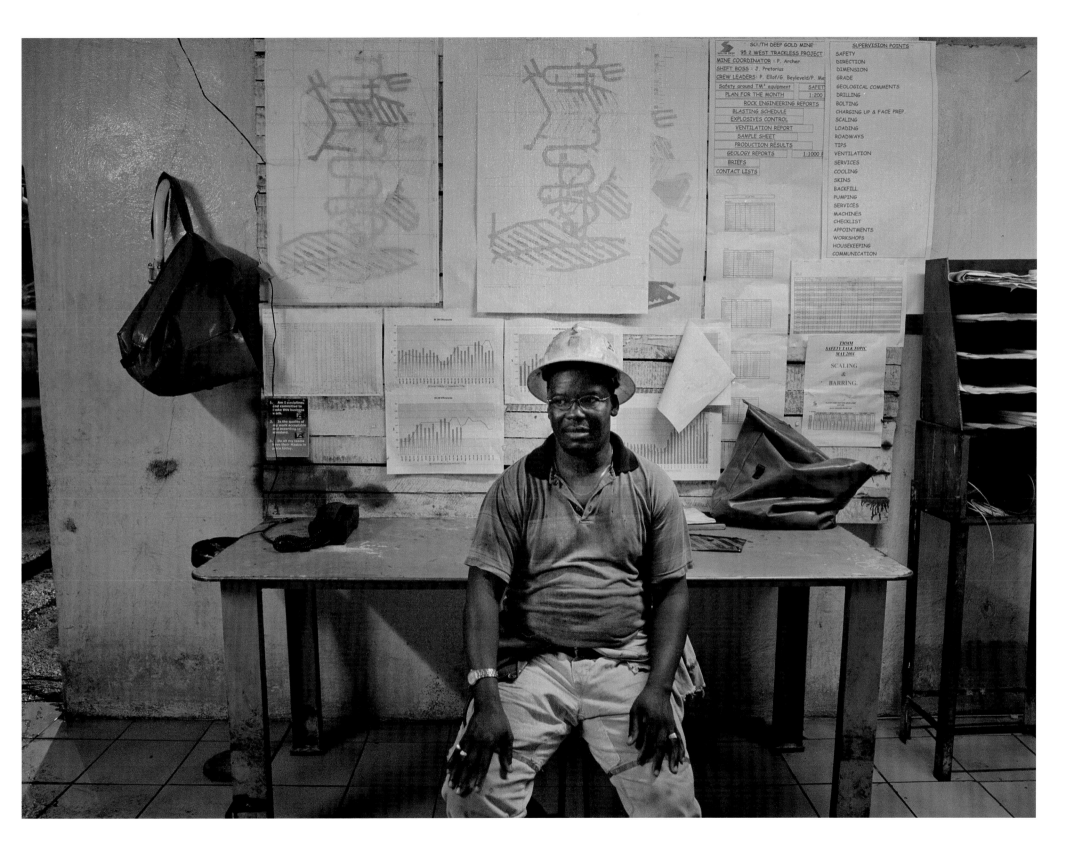

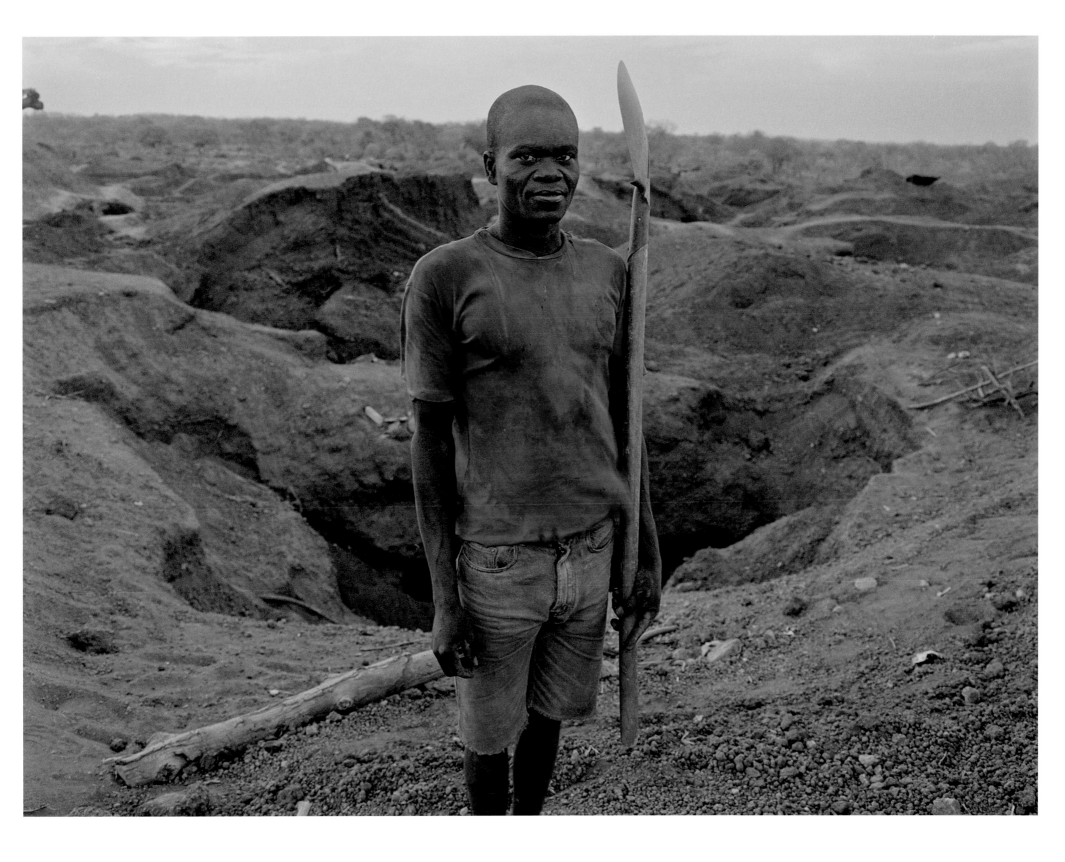

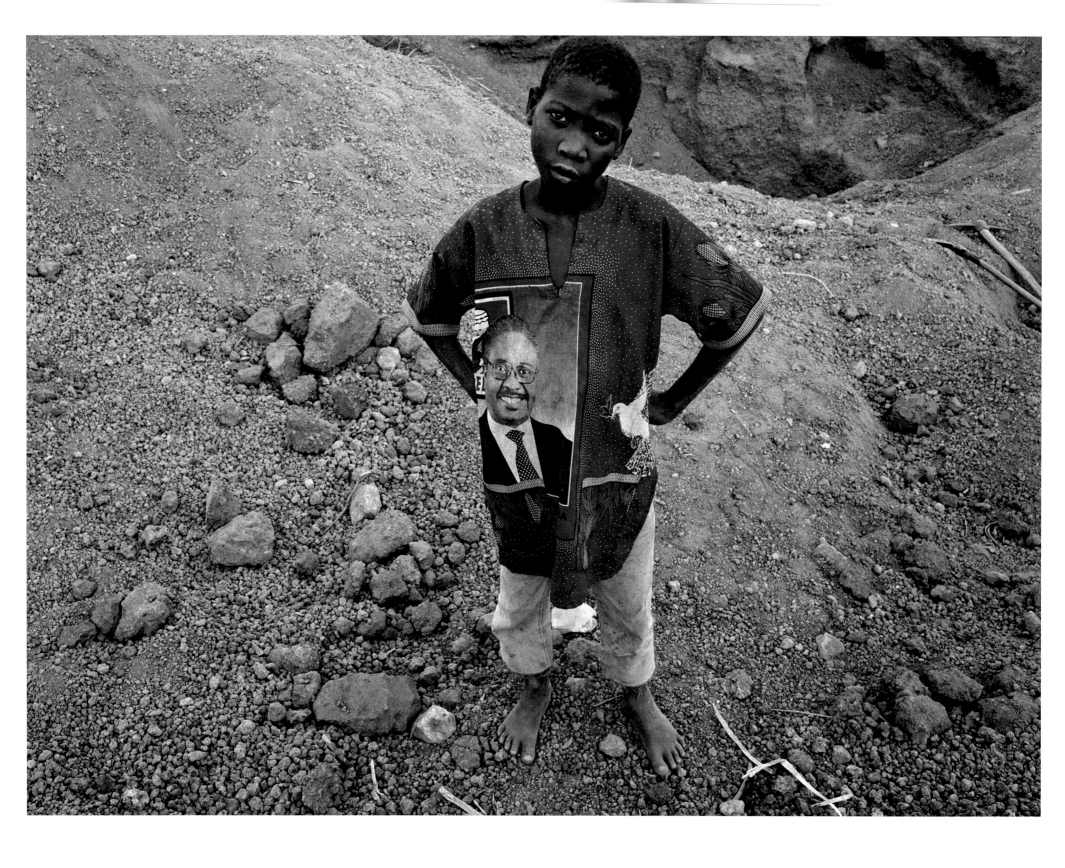

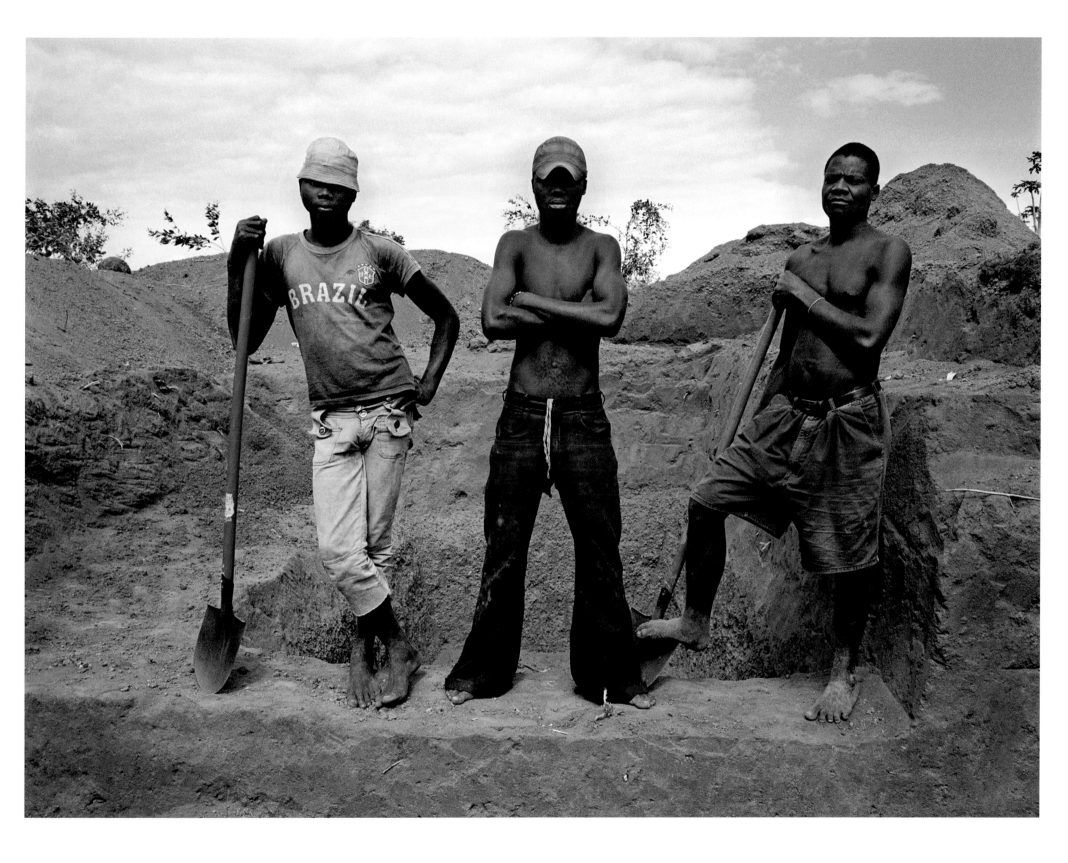

From the series Coal Miners, 2008

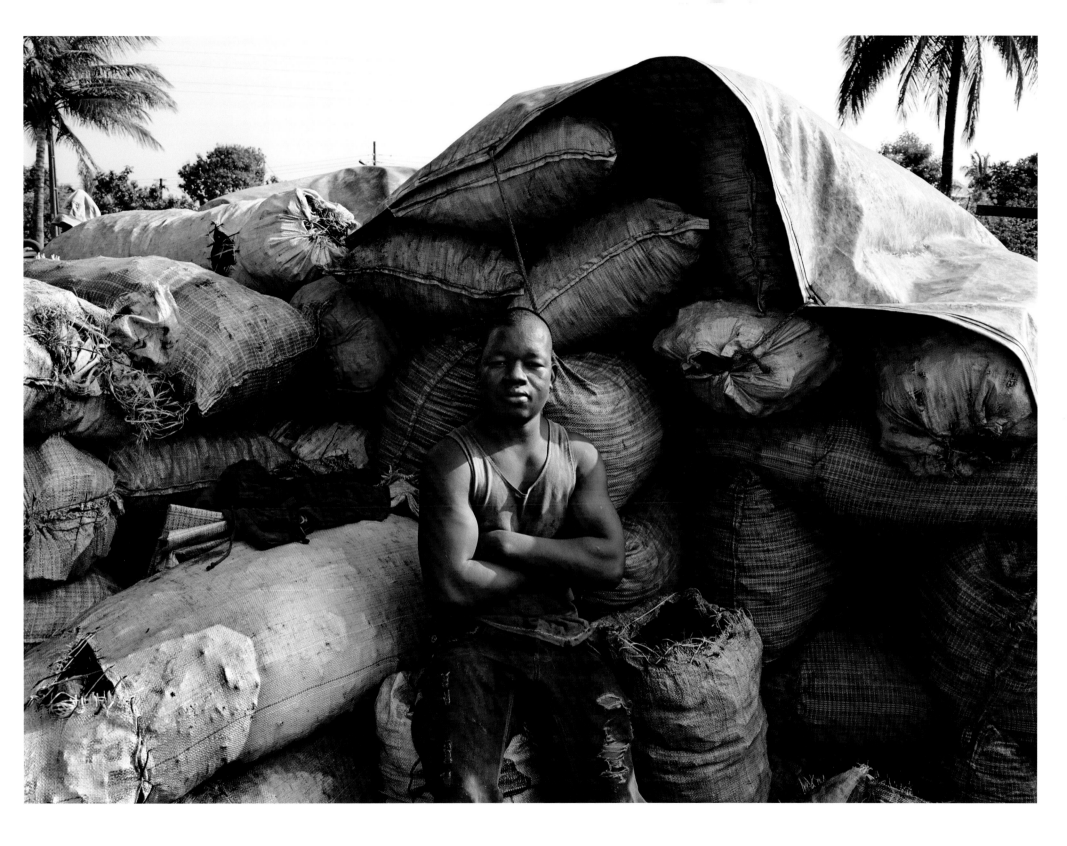

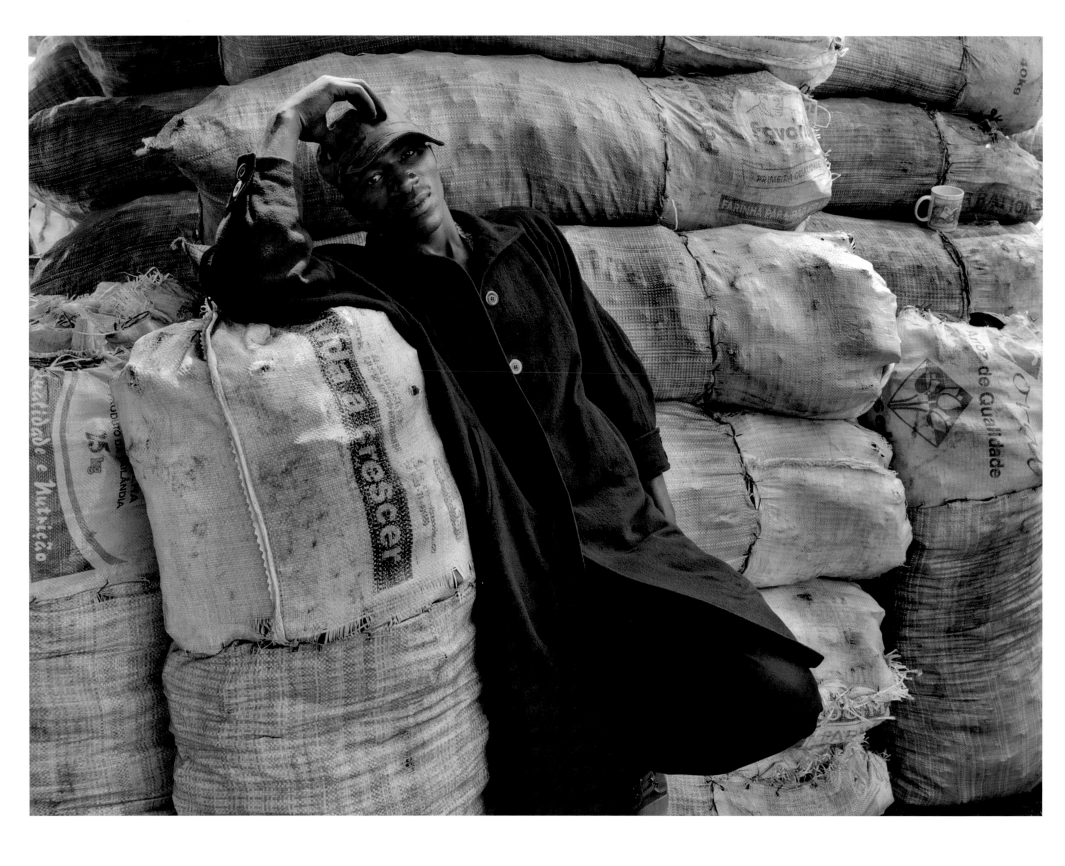

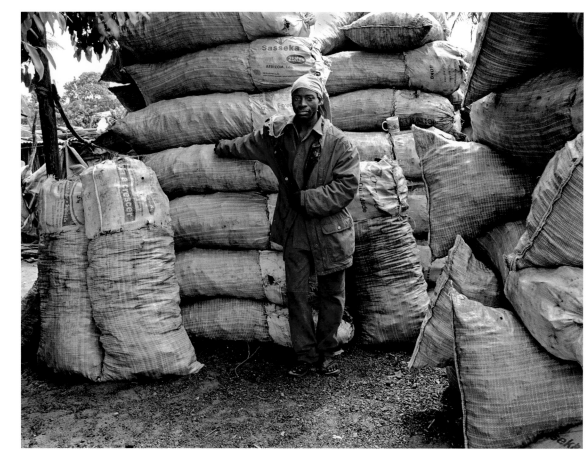

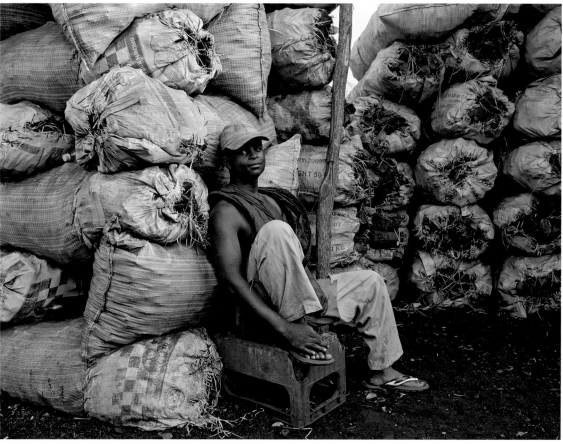

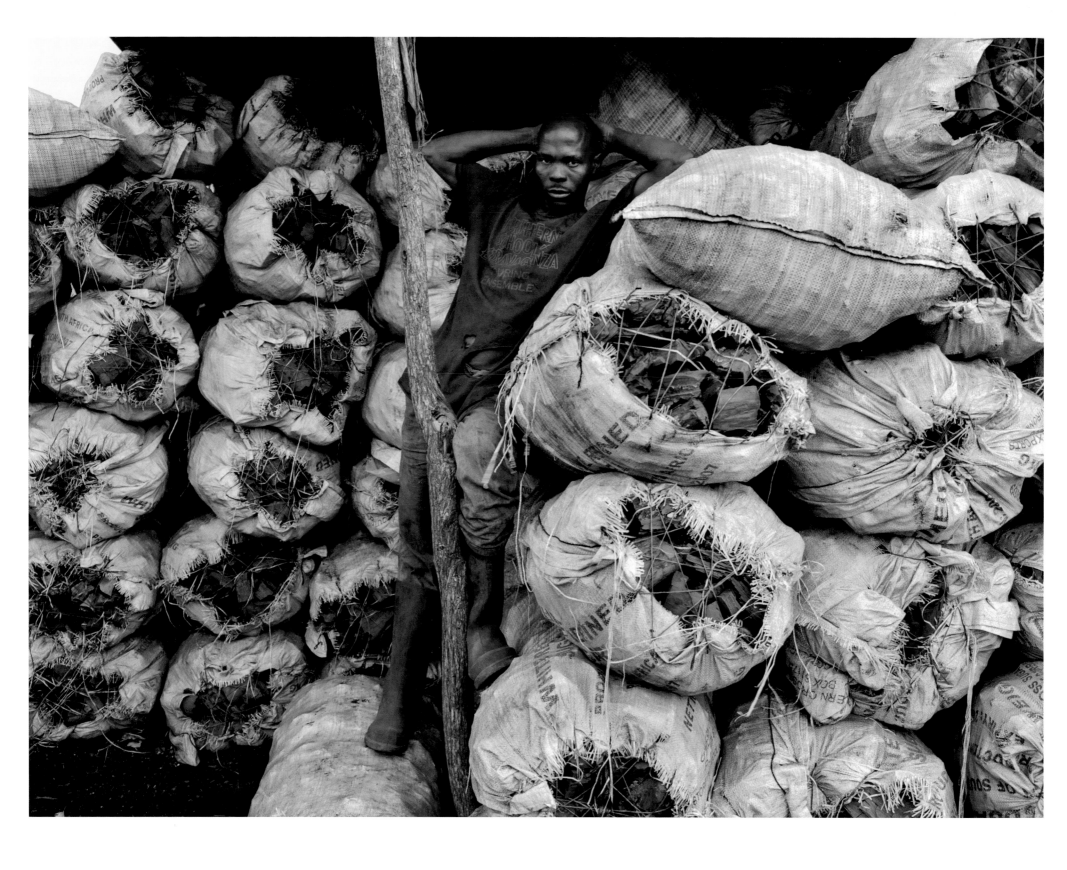

From the series Common Ground, 2008

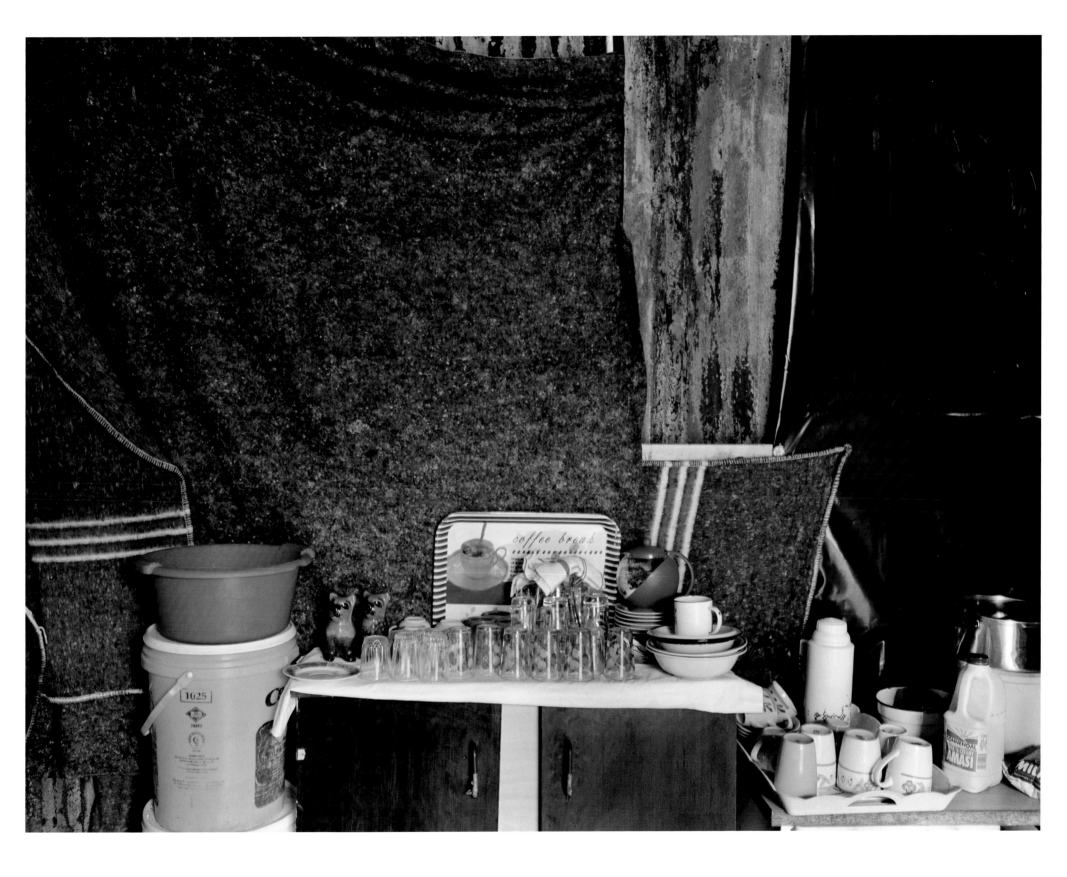

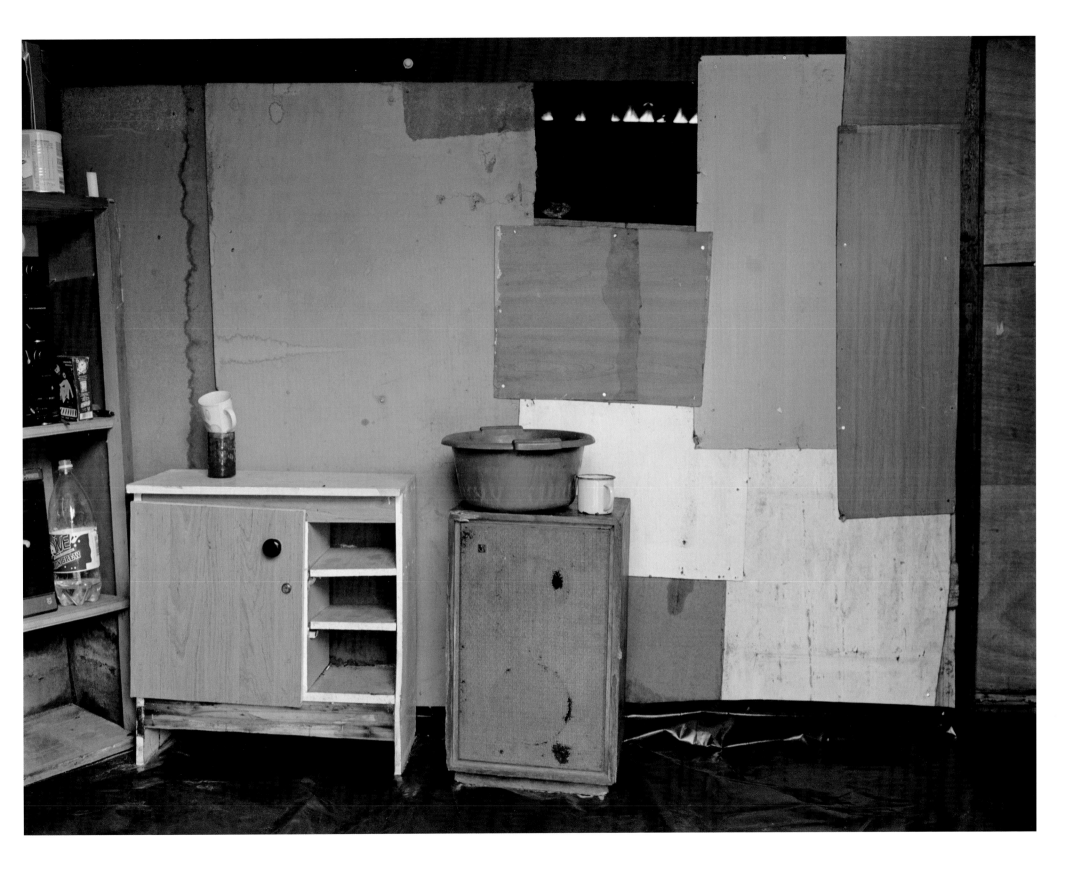

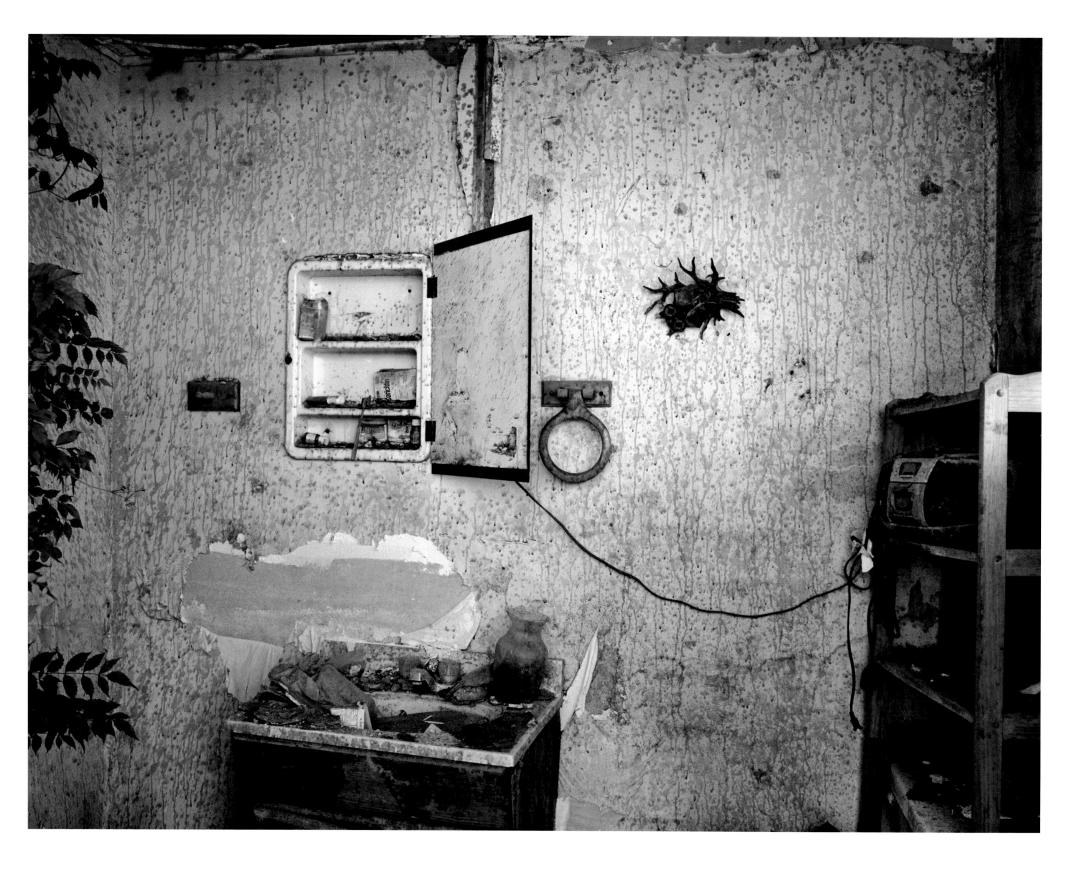

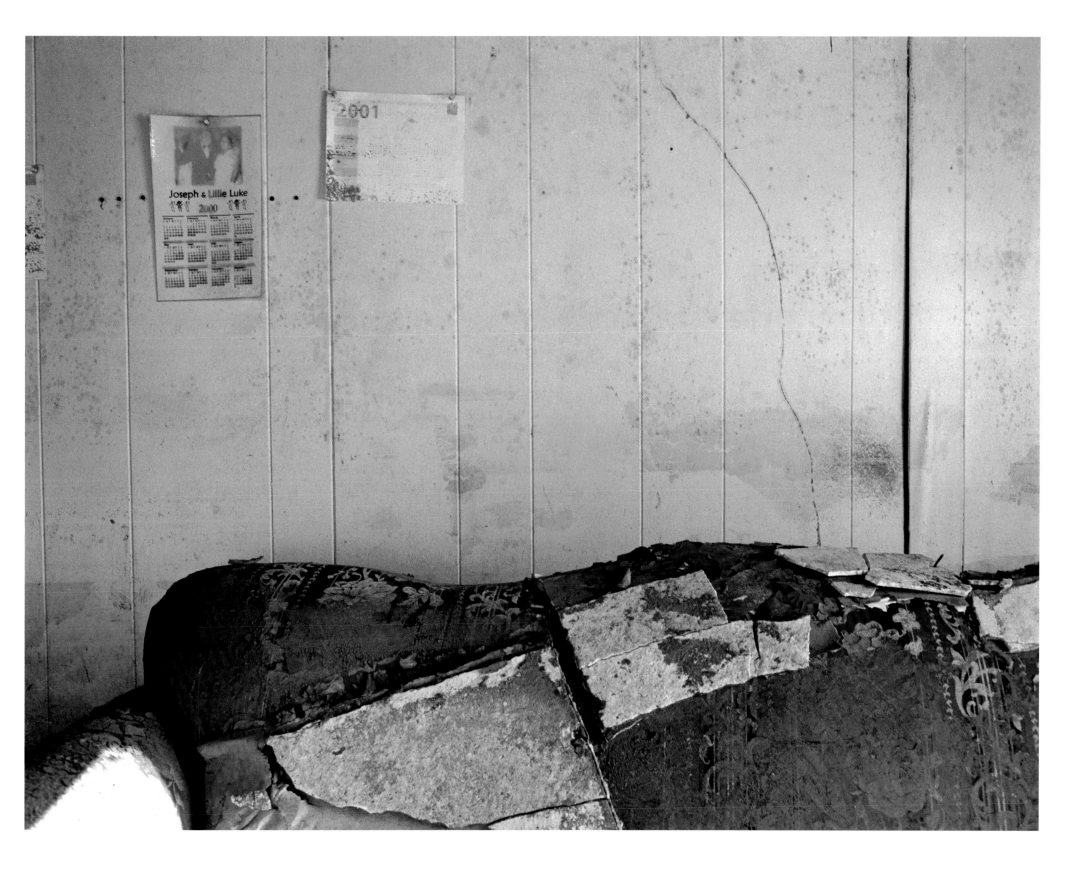

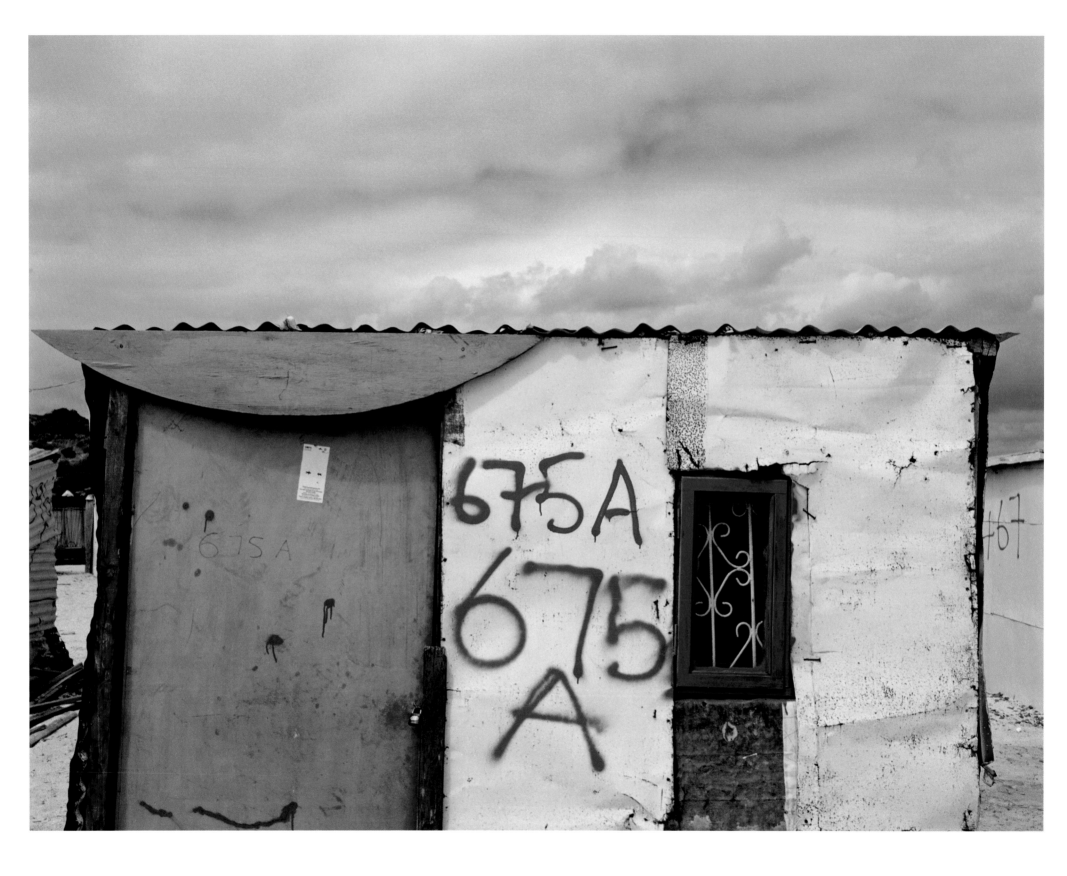

A CONVERSATION WITH ZWELETHU MTHETHWA

Isolde Brielmaier

Isolde Brielmaier: What were your initial ideas and objectives when you first began your portrait works for your earliest series, Interiors and Sacred Homes?

Zwelethu Mthethwa: Photographic portraiture is perceived in many ways as conveying the "real" . . . it feels more real than say, painting or a drawing. What the camera records seems so much more objective. I wanted to use these qualities as a way of talking more in-depth about the people who I photograph. I wanted the subjects to look at the photographs and see something of themselves. I also wanted to project how I was looking at people; black South Africans on the periphery; those on the margins of South African society.

IB And who are these individuals exactly? Where in South Africa did they come from and why did they come to the cities?

ZM Individuals who reside in the townships or informal settlements located on the outskirts of the city. Many of these people come from the rural areas like the Eastern Cape, which is the main settlement area or province for Xhosa-speaking people. Before the first free elections in 1994, there were laws that governed who could live in the cities and who essentially had to remain on the outskirts of South Africa's urban areas. After the elections, these laws were lifted and we saw a huge influx into the cities. People came to the cities with the primary objective of finding work and a way to support themselves and their families. They are essentially migrant workers because every holiday they go home. Most of them have a lot of family and strong ties back home. They also have certain cultural practices that they adhere to. For example, when they die they are taken back home to the rural areas and are buried there. When they retire they also return to the rural areas. Though the younger generation born in the settlements, and the folks that came to the cities when they were very young, tend to regard the city as their home, overall these new people were seen as different. They have particular customs, they speak different dialects and have different identities and traditions and all of these differences contributed to their marginalized status.

IB So why did you decide to focus on these communities? Why take their portraits? And what was the nature of your interaction with these sitters?

ZM When I visited these settlements outside the city, I saw a lot of positive elements about who these people were and how they were living their lives. In my work, it was my hope to try and empower these individuals in some way. I asked them if I could take their photographs, and I also asked them to collaborate with me in the making of their portrait. Often they would ask me to come back in an hour so that they could wash and change their clothes, and I was happy to do this because it adds to their comfort during the shoot. It was important that I offered them the chance to decide how they wanted to be photographed, and in this way it became, in a sense, about giving them back their dignity and authorship. Their homes were not made of brick and mortar but rather more fragile materials like cardboard and corrugated tin. But their spaces were immaculate and they used colorful coverings and designs for their wall décor. I wanted use color film to bring out the vibrancy of their lives and the care and pride that they put into how they are living. When I finished these photographs I would shuttle back and forth to the settlements to make certain that these people got a print of their image—usually 6 by 9 or 8 by 10 inches. Many of my sitters often used these photos as a "living document," which they passed along to other family members who lived in the rural areas. Their portraits were proof of who they were and how they were living in the city.

IB It is interesting to note that while you remained focus on the identities of your subjects; on articulating their individuality visually, you labeled the images in Interiors and Sacred Homes as "untitled." Can you discuss the significance of this?

ZM I come from a culture where the collective is more significant than the individual. It is really about who people are connected to, where they are from, and what work they engage in. So, the idea of labeling work as "untitled" is about keeping the focus on the collective, the idea of unity and community. And "untitled" for us as viewers

also sparks further inquiry in terms of who and what is pictured in the actual portrait. Giving the first name and last name of the person can also be somewhat misleading, particularly in South Africa, as some people change their names because of perceived social and political pressures. In many cultures in Africa, when it comes to identifying a person, one does not look at the person themself but rather how they fit into their larger community structure. Even in an oral storytelling situation, the basic narrative is told by the narrator but the story is embellished by the listeners—the larger collective. By calling my works, "untitled," I was trying to offer the basic narrative and then allow the viewer to embellish the story with their own experiences and place the people whom they are looking at within an environment which they can relate to.

IB And then there is the series, Empty Beds, which features no people at all . . . what were you after in this body of work?

ZM I started to photograph the Empty Beds series in men's hostels around Durban. In every city in South Africa, we have hostels that were established by the government to house only male migrant workers coming from the rural areas to the cities. Their family members were not allowed in the hostels, and so most of them stayed in the rural areas. These very hostels are currently being converted into family units. With Empty Beds my interest was exploring how these migrant workers lived, and how they shared their spaces. Later on, I continued that interest with the informal settlements [the Interiors series]. The bedroom and the bed is the most private part of any home and this series endeavors to look at how the men created privacy in a communal living area. One of the intriguing aspects of this series has been the way that the men have decorated their beds. Without meeting the owner, you would think that the bed was owned by a woman, since the men use feminine colors that contradict the gender stereotypes. But each bed and room remains unique and speaks to the individual who resides there.

IB In addition to the strong collaborative aspect to your practice, your focus seems very much on highlighting and making a connection

between your subjects and the environments in which they are situated. How does this aspect evolve as you shift your focus away from say, the private space of someone's residence, to a seemingly more public space such as you have done in your series on sugarcane fields, factories, or mining areas?

ZM I think that my more recent series—following up with a focus on public spaces—is a natural development. It allowed me to move from very intimate spaces, which have to do with individuality and the family unit, to exploring how the individual and the family unit function within their broader work and community environments, the public domain. The two components together give a more informed and well-rounded overall portrait of the people photographed. This all-encompassing focus speaks more to how the sitters' identities are shaped, and makes them three-dimensional, rather than presenting the two-dimensional entity of a simple vote on a ballot paper.

IB Can you speak a bit more about moving your work and your focus on these more public realms across the borders of South Africa?

ZM One of the major elements of the political shift in South Africa is that it gave a new position to the country within the African continent as a whole. It opened South Africa's borders to the neighboring countries, and this changed the composition of South Africa's cultural and economical outlook. Looking beyond South Africa gives me a chance to examine the relationship between say, Mozambique and South Africa, and I am only just beginning to scratch the surface of this new area in my current work. Presently, the direction of my work is to continue to look more at South Africa's neighboring countries and to try and understand their relationship with South Africa, especially given that there is a lot of migration across the borders, which then forces South Africans to deal with problems outside their zone of familiarity and comfort. Although it seems that it has been a long time since South Africa became a fully democratic country, in terms of general history, it has actually been a very short space of time, it will take years to formulate and carry out policies. I think

that at the moment, the government and the people are not on the same page, and although the ANC began with a very strong grassroots connection with the people, this connection and the communication that comes with it, seem to have been lost. The people's frustration is that the ANC has failed to make a smooth transition from being a liberation movement to being a political party. This is reflected in the influx of immigrants, and the shortage of housing still, and the related problems with unemployment and xenophobia. These are all issues that I'm exploring in my work as I move forward.

IB So the miners series you completed in Mozambique allows you to get at some of these concepts and relationships?

ZM Actually, there is a phenomenon in African politics where people speak of "southern African countries." The borders have become very loose and more fluid. There has been a lot of trading between these southern countries, and many people say, from Mozambique, have actually worked, or are working in the mines of South Africa. People from Maputo shop regularly in South Africa . . . there is constant border-crossing and exchange. The miners that I captured in the series come from all over the continent . . . people come from Nigeria, Somalia, and so on. It is only natural that people come to where the currency is; to where there is work and money. There, land is owned by the government, but in many places around Africa there are mining areas that aren't owned by anyone, and nothing is regulated. It's a free-for-all. It is not controlled mining. So, I'm after all of this in these images. I am looking at identity, economics, and exchange, and how this impacts a broad range of people across countries.

IB In extending your work beyond South Africa's borders and into the broader world, the work you did in New Orleans for the *Prospect*.1 biennial in the fall of 2008 adds yet another dimension. How do you see these images in conversation with your Africa-based work?

ZM Before I got to New Orleans I had already completed a body of work. I had been there before Katrina, but when I got there post-Katrina, I realized that I needed to do something more current, something

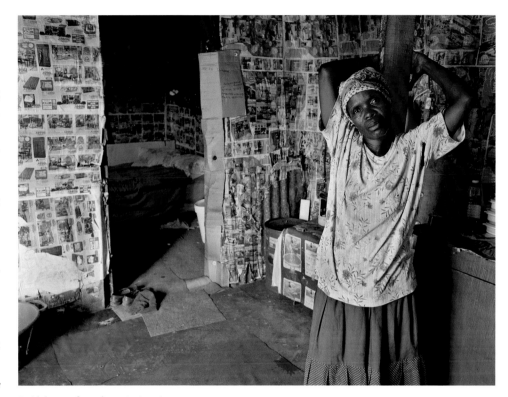

Untitled, 2003, from the series Interiors

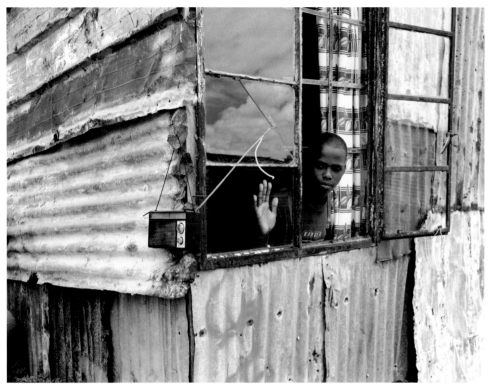

Untitled, 2008, from the series Common Ground

that was relevant to what had just happened. And to make them topical to me, I wanted to relate these New Orleans photographs to what was happening in Cape Town. Both cities are in the south of their respective countries, and the land and homes belonged to those who were marginalized . . . there were so many similarities. Both places were beset by natural disaster, I saw homes that had been destroyed by flood [New Orleans] and wildfires [Cape Town]. In a sense I was trying to create a bridge of commonality between two very different, but also similar places and circumstances.

IB It should be noted that photography is not the only medium in which you work. Can you talk about some of your video work, and how that work relates to your broader practice?

ZM I really see video as extending my artistic language. With *Flex* [p. 98], for example you see a body moving on the screen, but you can't really tell what is happening. You are forced to create your own story and add your sound; you as the viewer become an active participant in creating the story. With *Crossings* [p. 98], you have three screens—three dimensions, or three different settings. Visually I was trying to mimic how one looks at one thing and then another, all in real time. There is a focus on the shoreline, on the river, and then on the detail of the baptism, and this all makes the viewer aware, highly aware, of his/her position. The dynamic between the subject and the viewer is always so important. And actually, while video is capable of this, I use the large-scale of my photographs in a similar way.

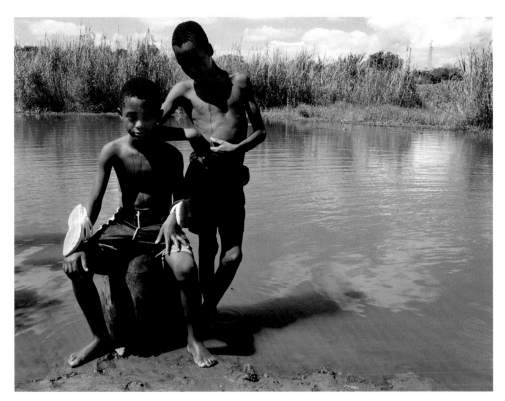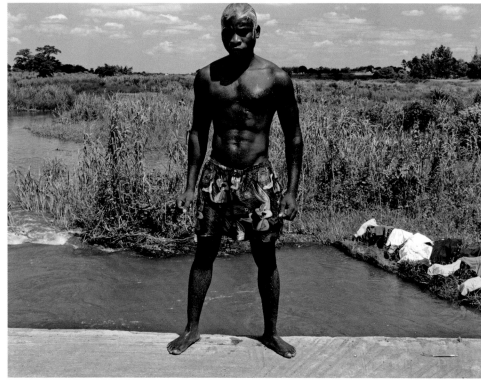

Left and right: *Untitled*, 2007, from the series Mozambique/The River

Above: Video stills from *Flex*, 2002

Below: Video stills from *Crossings*, 2003

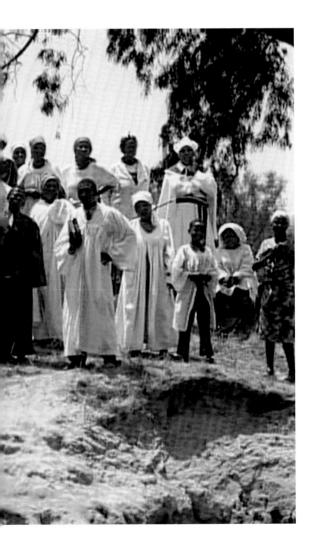
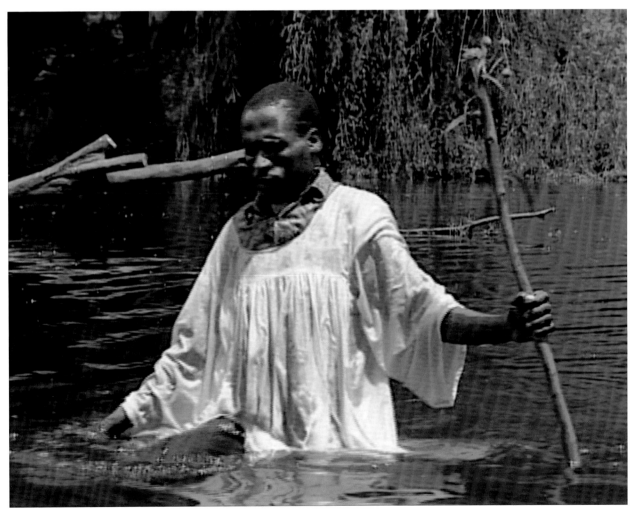

PHOTOGRAPHY AFTER THE END OF DOCUMENTARY REALISM:
Zwelethu Mthethwa's Color Photographs Okwui Enwezor

Ubuntu, Humanism, Photography

South Africa's often-told story is always framed by the experience of apartheid. No account or rendering of the society, its peoples, its cities, and the natural world it occupies—especially its landscape—escapes the savage fact of the political misadventure of settler colonialism or is untainted by the metastasized ideological cancer of racial segregation and the attendant social violence incurred by the society. Writing about works of South African art always seems like walking down a cul-de-sac. At the end of the one-way street, what one finds is South Africa's anguish. Due to the sharp contrasts and discordant tensions that defined the social conditions of the entire society, modern South Africa has been a fertile ground of high human drama, entwining the lives and existence of colonizer and colonized, oppressor and oppressed alike. Over time, this situation accumulated an iconic aura centered on accounts of the impoverished life it spawned. These accounts, in turn, manifested an enduring image economy that served as proof of the moral debilitation that was apartheid. Photography was always at the ready to examine the nature of this relationship between the iconic and the impoverished.[1] It profitably exploited the convergence, feeding on neglect and debilitation. These in turn generated an iconographic landscape that trafficked in simplifications, in which moral truths were posited without the benefit of proven ethical engagement. In a sense, photography suffered from myopia.[2]

Critics such as the writer Njabulo Ndebele have observed that the binary logic of apartheid—often dramatized through forms of abject dehumanization—provided an environment in which crude spectacle and social exhibitionism became the norm of literary and cultural representation. In his searing indictment, Ndebele finds such representation nothing more than a shipwreck of excess, an impoverishment of the imagination. As he puts it, "The spectacular documents; it indicts implicitly; it is demonstrative, preferring exteriority to interiority; it keeps the larger issues of society in our minds, obliterating the details; it provokes identification through recognition and feeling rather than through observation and analytical thought; it calls for emotion rather than conviction; it establishes a vast sense of presence without offering intimate knowledge; it confirms without necessarily offering a challenge."[3]

Artists, writers, and photographers alike wrestled with this critique,

as did the audiences of South African art and literature. Not even the most oblique and abstract works were entirely insulated from the debate—at least, not by simply avoiding dehumanizing spectacle. Like most art produced in extreme sociopolitical situations, South African art seemed beset by an anxiety, guided as it was in many instances by social responsibility.[4] This can also be summed up as the anxiety of humanism. As art historian Colin Richards writes, the challenge of humanism in South African art derives from "a fuller recognition of violence, of the trauma it occasions in our artmaking, [and] is part of what it means to be human."[5]

It was no surprise, then, that Zwelethu Mthethwa, one of South Africa's leading contemporary artists, should begin his career by seeing a path that led to a cul-de-sac. He confronted this by drawing an ambivalent line between his artistic intentions and reportage, especially the kind of brutal, grainy realism normally associated with black-and-white documentary photography.

At first, Mthethwa avoided photography entirely. His early work was composed of paintings executed in vibrant pastel colors. The imagery and subject matter was almost exclusively drawn from black rural and township life. These paintings had a winning appeal; they were easy on the eye. Their vivid, rich colors evoked the influence of South Africa's great modernist painter, Gerard Sekoto. But unlike Sekoto, whose paintings were unambiguously political, Mthethwa's evinced a colorful, figurative style that was politically ambiguous and hewed toward a romantic depiction of black social existence. The subject matter of these pastel paintings offered the viewer an air of soft, proletarian humanism.

These paintings, and the scenes portrayed in them, employed a kind of picturesque sweetness common to postcards of exoticized places. An untitled work from 1996 depicts a backyard scene of drying laundry flapping in the wind, with strategically placed figures of three naked children in plastic washbasins watched over by an earthy black mother; *Madonna*, 1994, a family portrait of a man and a woman cradling a child, is another one of these standard depictions.

These were the kind of images that defined the early portion of Mthethwa's career until 1996, when his ambivalence toward photography shifted.[6] Though he was trained as a photographer,[7] Mthethwa's avoidance of photography emanated from an aversion to black-and-white reportage. In 1996, his response to documentary photography's presump-

tions of truth-seeking detachment and objectivity was a series of power-ful and striking photographs in deep, saturated color. Yet this choice was connected to how the policies of apartheid delimited the options of black artists in its institutions.

As Mthethwa recollected, his early beginning as an art student, engaged in the formal artistic study of photography at a white institu-tion, was itself circumscribed by a legislative fence: "In 1980, in terms of the law, to study at a 'white' institution like the University of Cape Town, I had to take a course that wasn't offered at a black university. So I chose photography." Here, he confronted two realities of the black artist under apartheid. First, in terms of education and technical training, for black artists photography was seemingly off-limits. To acquire that competence, artists like Mthethwa had to overcome the law, for the law was the first limit. Second, if and when he gained that competence, the black photog-rapher with artistic intentions beyond recording the stock images of the documentary industry had to overcome the types of imagery set up by the rules of the law, namely the apartheid condition. This situation called for delicate negotiation, and set up a double ambivalence for black artists: toward the law, and toward the image economy, which was derived from the ruthless attempts by the law to defeat black subjectivity. Mthethwa continues:

"I struggled at first, but ended up majoring in photography and even-tually did an MFA at Rochester Institute of Technology in the U.S. When I came back at the end of 1989, I found it difficult to take photographs. I didn't want to be a photojournalist. I wanted to be a *fine arts photogra-pher*, but I wasn't making enough money to keep my photography alive. So I stopped taking photographs" (author's emphasis).[8]

There is an apparent tension here between what "fine arts" photog-raphy conveys and what "mere" photojournalism depicts. One seemingly operates within the rarefied vision of art as a context with no respon-sibility toward social commentary or moral empathy. The other is pro-duced solely as social commentary, in which subjects and situations become mere specimens and illustrations of a given moral code, a code to be transformed into advocacy for victims in need of sympathy. A fur-ther distinction between black-and-white and color photography could be summarized this way: the former tends to mediate, thereby historiciz-ing, positioning, and freezing its subjects in the past; while the latter is

consumed with the immediacy of the image, the encounter with the real, and thus tends to position its subjects in a shifting, contingent present. Paradoxically, it was the commercial success of his pastel paintings that liberated Mthethwa from the narrow artistic convention he had adopted. It also stoked his return to photography. He explicates the reason why he finally came to embrace photography:

"It wasn't until I started selling my drawings that I had money to invest in photography. In 1996 I started taking photographs again. I started tak-ing colour portraits at Crossroads—an informal settlement outside Cape Town. Photographs of informal settlements prior to the elections in 1994 were mostly black-and-white images. The photographers weren't shooting for themselves, they were on assignment and black and white was used to suit political agendas of the time. For me, these images missed a lot of the colour of informal settlements. I wanted to give some dignity back to the sitters. I wanted them to have a sense of pride, and for me, colour is a dignifying vehicle. The fact they've allowed me into their personal spaces meant that I had to dignify them."[9]

In responding to what he perceived as the undignified manner in which black-and-white imagery situated its subjects, Mthethwa was clearly reflecting on the relationship between photography and humanism. In a way he was responding to *ubuntu*,[10] a philosophical idea derived from Zulu that defines intercultural and interhuman relations; it describes how human beings respond to each other in social contexts. In a sense, *ubuntu* not only frames, it is, in the classical definition of humanism, an affirmation of human dignity. The call for recognition embodied in *ubuntu* is captured by the Zulu phrase "Umuntu ngumuntu, ngabantu" (A per-son is a person through other people).[11] This is not unlike the philosopher Emmanuel Levinas's idea of "being for the other."[12] These articulations of humanism and concern for the other register powerfully in the struggle between black-and-white photography, as a medium that sets up its sub-jects as anthropological case studies, and color, which allegedly contests the anthropological tendency of reportage and restores its subjects to their position as people with proper names and proper places—that is to say, as humans.

The point about humanism and dignity conceived through the prism of the photographic image is salient enough. However, there is a presump-tion here, articulated in Mthethwa's overarching statement that it was

his place, as a sort of white knight, to give back dignity to his impoverished black subjects. The distinction between these two pictorial motivations is especially significant for any black artist operating within the institutions of apartheid, whereby separate amenities were also translated into separate representations. For white subjects, the relationship to representation was directed at modernity, toward the depiction of sovereign subjects, while for blacks the obverse obtained; subjects were either tribalized or placed at the margins of modernity and sovereignty.[13]

Sovereign Subjects:
Portraiture, City, and Citizenship

Humanism in Mthethwa's portraits, in essence, is preoccupied with questions of sovereignty. There often exists, in societies where class and political structures are rigidly maintained—as in South Africa before the formal end of apartheid—a strain in social relations between common inhabitants of a place, nation, or city. Such strain is most present in instances where social divisions are produced by racial determinations, and maintained by onerous economic and political structures generated by the edict of the law. For example, in the United States during segregation, under the Jim Crow laws, African-Americans were made targets of legalized exclusion in housing, places of employment, and public facilities such as theaters, restaurants, and transportation by states and cities, as were the Jews under the Nuremberg Laws introduced by the Nazis in 1935. The laws of apartheid in South Africa similarly deprived Africans of all rights to the city, beginning with the Group Areas Act.[14] A corollary act, the Separate Amenities Act, followed a few years later.[15] For those dispossessed of rights to the city, all claims to citizenship became tenuous; their very existence was constantly troubled by social invisibility, if not outright political nonexistence. The light of the law was opaque to their condition. Under the rules of apartheid, the law specifically denied all nonwhites—and particularly black Africans— without a legally stamped passbook (the notorious *dompas*[16]) access to the city. These rules abrogated any claim to citizenship, and made access to the city difficult to attain without the aid of the law. The law effectively confined black Africans to the outskirts, placing them under permanent

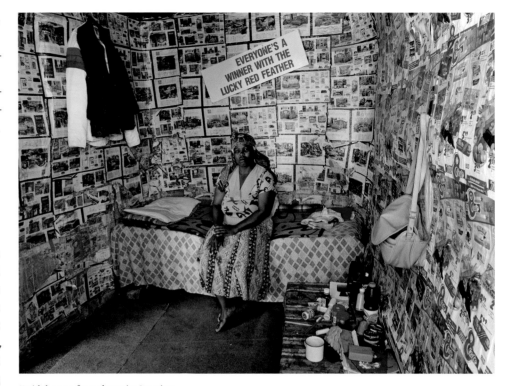

Untitled, 2003, from the series Interiors

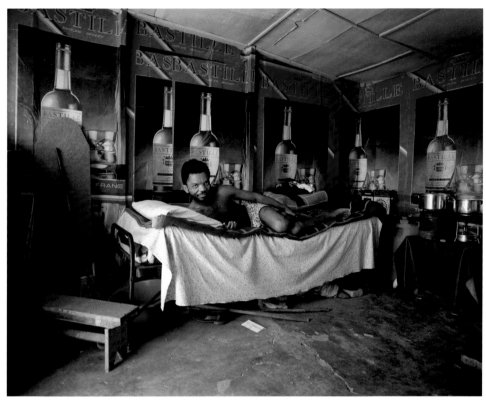

Untitled, 2003, from the series Interiors

displacement, ban, and exile from the city—literally transforming them into noncitizens.

Given these circumstances, how does portraiture operate in a society marked by such deep antipathy toward the abjectly racialized, the poor, the dispossessed, the migrant, or the noncitizen? This question might be asked in regards to Mthethwa's portraits of the inhabitants of the informal settlements situated on the outskirts of Cape Town. The critic and art historian Rory Bester responded to the existential state of the black subject with regards to claims to the city and citizenship in an insightful essay that explored how black subjectivity was molded under the policies of apartheid, writing that "the establishment of an opposition between notions of modernity and tradition, and more specifically the subordination of tradition to modernity, are narrative threads repeatedly woven into the social fabric of apartheid South Africa."[17] Settlements like Crossroads—a vast shantytown of rickety, unstable architecture, mostly built out of scavenged scraps of wood, metal, cardboard, and plastic, where many of the earliest portraits were shot, represent an opposition between tradition and modernity. As Bester noted, "Controlling and limiting the influx of black South Africans into the city in this way became a substantial (but not impervious) means of enforcing the socially engineered map of apartheid."[18] Like mapmaking as a device of social control, the lack of belonging to the apartheid city engineered its own blighted representation of the indigent black figure. In this way, "for black South Africans, the apartheid city, with all its physical allusions to modernity, embodied the denial of any claim to citizenship."[19]

This is a significant point. According to Mthethwa's theory of color photography, black-and-white reportage was itself complicit in denying the indigent inhabitants of settlements like Crossroads any claim to subjecthood. It placed them within the status of news items: victims rather than persons, specimens instead of individuals. In so doing, black-and-white reportage placed these men and women—already deportees from the apartheid city—outside historical time. Color photography, on the other hand, restored that detachment from history, making them contemporary once more. It performed the magic of representing them in the present, alive in Technicolor, with or without the aesthetic allure of the decay and physical decrepitude of their environment. To Mthethwa, it mattered little whether his subjects inhabited palaces or suburban bungalows. What

mattered most was that he photographed them in familiar surroundings, namely in their own homes. This latter point features prominently in the lavish treatments he gave to both individuals and their homes.[20]

In light of this intricate dance between photographic processes, it might be productive to explore the link between the subjects of these early photographs and issues of portraiture, city, and citizenship. One must remember that in classical Greece, the city (polis) was delimited only for free men, thus the origin of the idea of citizen: one who belongs in the city and is lawfully recognized as such. The right to dwell in the city confers citizenship. Under the laws of apartheid, black South Africans lost the right to dwell in the city and therefore had no claim to citizenship. By thinking of all these issues, along with the fact that to be allowed to study in a "white" university, Mthethwa had to prove some deficiency in a "black" institution, we might understand the deeper investment Mthethwa brought to his pictorial project of individualized collectivity. His quest to photograph his subjects in color relates at a profound level to the dignity he spoke about; namely, the recognition of the human capacities of his subjects. One such capacity is the right to citizenship, even if it may be in an informal settlement, which is no less a city than any other city in South Africa. This is not unimportant, as we shall see later in his images.

Urban Memories:
Architectures of the Dispossessed

It could be argued that under the conditions of social exclusion in which the inhabitants Mthethwa was photographing in 1996 at Crossroads existed, the urgency of portraiture was not only to convey dignity, but also to place the inhabitants back in the gallery of the city's memories. Here, portraiture took on a remarkably honorific logic. Being photographed conferred upon the figure in a portrait the stature of subjecthood. It was as if the portrait placed a light of visibility around participants in the photographic project.

One of the earliest images in this series, posed in the vivid interiors of one of the homes, makes the point loud and clear, literally. The photograph (opposite) is extravagant; a theatrical tableau composed within an undisguised ramshackle room constructed out of nothing more than corrugated cardboard, with a compacted dirt floor.[21] The backdrop of the environment explodes with fiery amber and gold, against a deep blue velvet field, around which a band of royal red frames the image of a large bottle of cheap French brandy and a cut crystal glass in which the golden spirit sits like molten lava amid blocks of ice cubes. This florid backdrop was salvaged from a disused advertisement billboard for Bastille Brandy, and employed as wallpaper to humanize the humble shack and bring a bit of ersatz glamour into it.

Despite its striking decor, the room is spare. It contains only the barest minimum of possessions. To the right, there is a low wooden table covered in dark blue plastic on which two metal stoves (one blue, the other silver) sit, and upon them stand two gleaming aluminum pots; a blue plastic drum, a radio-cassette player, a folded pile of blue and white blankets. Underneath the bed rest a jumble of objects: a mud-encrusted black shoe, wooden sticks, and a blue plastic washbasin. To the left, next to a low wooden bench, leans a composite board, with a broom resting against it. Nothing more is in the room. What grounds the image, however, and gives the viewer pause is the subject of the photograph. Depicted in an offhand but carefully composed casualness, a bare-chested young man, perhaps in his thirties, wears nothing but a pair of patterned boxer shorts. He is lying on his right side on a bed that is carefully made with a floral coverlet and a geometrically patterned maroon blanket. He looks out attentively to the camera, his left knee folded and jutting out into the frame, his left arm languidly stretched out at his side. There is a double gesture in the staging of this photograph: it reveals a tentativeness, even stiffness, in the carriage of the young man that sublimates vulnerability and tough masculinity. It presents the man, whose name, identity, or occupation is unknown to us, not only as a fantasist but also as a subject without the armor of social stability. Yet this portrait session was planned solely to celebrate the portrayed as he wished to reveal himself, proudly in his home. It is not a judgment of his contingent circumstances, nor of his impoverished domestic quarters.[22] Rather he is a character in search of a role in the field of masculinity.

Like his paintings, Mthethwa's photographic portraits reveal a proclivity toward typologies.[23] Another photograph, *Untitled*, 1996, suggests a trumped-up masculine demeanor similar to that of the man reclining in bed. Here another young man, clad in a red robe, with a cigarette between

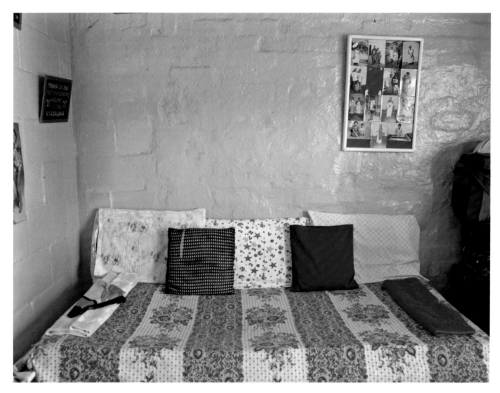

Untitled, 2002, from the series Empty Beds

his fingers, lies on a sofa that is wedged between a table and the wall, suggesting the narrowness of the rectangular room. Mthethwa uses depth of field to capture and encapsulate the sitter in his environment. In the immediate foreground is a still life of sorts, comprised of several objects: a ceramic jug and two glazed dog figurines, arranged on a low wooden table draped with white linen cloth. The table rests on a strip of woven, fringed rug, with horizontal bands of black, white, and gray stripes. The rug itself is placed on top of a geometrically patterned black-and-white linoleum floor. Immediately behind, set against the wall on the far right corner, a taller table is covered with a blue-and-white cotton gingham cloth. All these decorative elements give the room a sense of carefully curated texture, color, pattern, and pictorial motifs. However, the most prominent element of the photograph is not the figure in the distant center of the image at the far back wall, but the vibrant red-and-white Lifebuoy soap wrappers that cover the three crooked walls in their entirety. Thus the image is as much a study of the interior architecture as it is a portrait of its occupant.

There is another issue to bear in mind with regards to the aesthetic function of these vibrant interiors: the way they cease to be images and become things in themselves, almost like objects, or anthropological installations. Thus juxtaposed, sitter and environment merge into one continuous pictorial elaboration, creating a tableau of optic tremor. These interiors have been examined critically in terms of the way the photographs tend to aestheticize the decrepitude of the spaces they record. As Annie Coombes suggests, "One of the difficulties with Mthethwa's work, compounded by its primary locus of consumption in the contemporary international art market, is that the decorative surfaces and often incongruous juxtapositions immediately aestheticize the interiors to a viewer susceptible to the ironies of Surrealist disjuncture."[24] Certainly, images such as *Untitled*, 2000 (p. 103), of a solemn-faced young woman seated in the middle of a sagging bed, beneath the prominent signage of a lottery slogan that declares "Everyone's a winner with the Lucky Red Feather," or that of a young man wearing a baseball cap and staring at the camera with nervous intensity (p. 33), underscore some of Coombes's concern. In both of these pictures the jarring, busy background sometimes makes it difficult to look at the sitters on their own terms; the surrounding cacophony tend to dissolve any sense of individuality. Yet it is necessary to appreciate Mthethwa's commitment to color in his documentation of these

scenes: black and white would have made the interiors far more dingy and despairing, more susceptible to reportorial disjuncture, while in color the settings explode in a kind of candy-tinted jubilation.

In other images, Mthethwa chose settings with a cooler, more subdued effect. Three are particularly noteworthy. The first, *Untitled*, 2004 (p. 23), presents a slender, bearded man in khaki shirt and black felt hat. He is seated behind a table, with his chin propped on one hand, while his other hand reaches forward, resting gently on the table.[25] Behind him is a mono-chromatic backdrop composed of panels of sky-blue-painted fiberboard. Hanging on the wall are several items of clothing, most prominently three blue sashes with appliqués of "General" in white lettering on them. These sashes perhaps identify the man as a high-ranking member of the African Zionist Church. The second photograph exhibits a similar ambience. Again, in *Untitled*, 2004 (p. 19), we find a woman reclining on a bed,[26] staring intensely and solemnly at the camera. Her room, composed simply of unadorned panels of corrugated cardboard, lacks the garish wall covering that is the dominant motif in many of the homes in these series.

This image, like the ones before it and many others, portrays, records, and captures the dramatic living conditions of the dispossessed legion of postapartheid laborers living on the edge of the globalizing South African economy and its fast-changing suburban culture of cluster homes and luxury townhouses. These images relentlessly expose living conditions that are at once precarious and inventive, making the resulting photo-graphs investigations into portraiture and architecture. The creative use of material, such as the decorative and pragmatic employment of printed wrapping paper for everyday commodities such as soap, supermarket coupon advertisements, magazine pages, and billboards, creates environ-ments of vernacular pop gone awry. These photographs represent exam-ples of what makes Mthethwa's portraits unique and authentic while at the same time exploiting the artificiality of the surrounding spaces in which his subjects are photographed. Nonetheless, closer scrutiny of the images, which were produced in quite intimate surroundings, hint at a level of discomfort. Though Mthethwa's idea is to dignify his sitters, most of them, unlike the young man reclining in his bed, come off stiff, uncomfortable, nervous. It is difficult to look at the spaces occupied by the inhabitants and not think of the deprivation that comes with living in homes like these in a country of such affluence.[27]

Scenes and Settings

As I have explored throughout, the tension between photojournalism and fine arts photography was fundamental to Mthethwa's decision to finally devote himself to photography in 1996. At that point, the political crisis of the 1980s had passed, and contemporary South African art had acquired a level of conceptual and formal complexity that permitted a return to representations that specifically utilized the camera in different ways from those of the era of resistance politics and art. However, it was one thing to wish to avoid the black-and-white documentary mode, and another to surpass it and say something compelling about the social conditions of black subjects in the postapartheid context. The portrait project and the environments in which its subjects were situated made for a rich and captivating pictorial discourse on the relationship between individuals and their habitat. Mthethwa subsequently extended his photographic analysis from specific, individualized representations to a more generalized inquiry into the multiple conditions of dwelling, especially of those living at the margins of postapartheid urban culture.

Mthethwa's Church series, which is set in makeshift and appropri-ated spaces, addresses the way in which various architectural spaces and the surrounding urban landscape were used to inscribe the presence and urban memories of the citizens of informal settlements beyond their homes, thus helping them lay claim to the city. Though some of the images are conventionally portraits, they also evince a more complex articu-lation of the instability of urban space. A number of the images in the Church series depict both individuals and ceremonies. Some, especially the portraits, are located in appropriated or repurposed spaces, such as school classrooms temporarily converted into a church. The subjects are all self-possessed, solemn, and display a dignified ease and rapport with the camera. One striking portrait shows two figures: a seated young man holding a black, leather-bound Bible, held with his left hand on his left knee, and an older man standing next to him, his right hand gently placed on the young man's left shoulder. Each man holds a tall, slender wooden staff, and are both dressed in uniforms normally won by members of the African Zion Church of South Africa. The colors of the uniforms establish their ranks: the younger man wears a blue robe belted with a fringed white sash, while the older man is dressed all in white, except for his sky

blue shirt and a deep blue sash worn across the shoulders and belted with a white sash. Other images present single figures of women seated next to tables with lit white candles, or congregants gathered in outdoor settings that seem less than ideal for spiritual worship. What comes across, though, is not just the humble surroundings occupied by the worshipers, but a certain spiritual tenacity that transcends the transitory quality of the gatherings.

Given the varied states of his portrait subjects' living conditions, it seems entirely appropriate that Mthethwa should have moved toward photographing some of the sentimental vignettes that are part of these homes, in a further attempt to lend them dignity. The result is a series of pictorial dioramas called Empty Beds. The various arrangements that make up the displays in each home—with the bed, of course, at the center of the overall composition—convey different narratives. For example, in one image (p. 11) the wall against which it is positioned is as much the center of attention as the bed itself, on which a carefully organized still life of stuffed animals and dolls (including Mickey Mouse) is laid out on a floral-patterned throw, on the edge of which rests a heart-shaped red-and-white pillow. Neatly arranged in several rows across the wall with its patchwork wallpaper are items of clothing—a three-piece suit with a red shirt and tie, another set of ties, several pairs of pants—on sagging metal hangers. Another photograph from the series (p. 106) shows a room built of sturdier material, a cinder-block wall painted a bright, cotton-candy pink. Against the wall, another neatly made bed displays a series of mismatched pillows carefully arranged in a horizontal row. Most prominent on the wall is a white frame completely covered with a collage of snapshot photographs. A large metal pan on a pink wall is featured in one image; in another (p. 36) a tableau comprises an unoccupied bed set against green-painted cinder-block and wooden slat walls on which are displayed several bags and a set of newspaper pages of footballers taped up with black masking tape. All these displays bespeak the attentiveness with which each home has been decorated. Judging from the solidity of the walls in these rooms, they appear several grades higher than the earlier interiors showcasing the inhabitants. What is clear in the images is that Mthethwa is interested not only in the specificity of the honorific portrait, but also in the quality of life of the portrayed, in which their homes serve as an important signifier of their sense of rootedness and stability in the city.

Empty Beds, despite the pleasant arrangements and visual exuberance the series presents, hints at a sense of discontinuity, the dislocation of memory, a diminution of the verve of the earlier portraits. In contrast to the earlier dramatic tableaus, the eerie emptiness of the beds projects a disconsolate air. Untitled, 2004 (p. 28), a study of wan light and weak shadows, communicates this quality forcefully. The bed in the image is less neatly organized. The wrinkles running across the surface of the bedspread, in eddies of distress, suggest traces of an absent occupant. Here the bed seems less empty, becoming, like the ambiguous bundle on top of which a tan T-shirt is laid, a surrogate for an absent body. Are these beds shrines or memorials? The very absence of figures in the photographs of Empty Beds hints at the idea of an evacuated space. This is strongly suggested and reinforced by the title, which in the era of the depopulation of black townships, villages, and shantytowns by the ravages of AIDS seems ominous. The prominence of the adjective empty is intriguing, leading one to wonder whether Mthethwa is concealing, behind the charm of the images, a more portentous message.

If this is the case, two other series—Common Ground and Contemporary Gladiators—are much more explicit about the impoverishment of South Africa's informal settlements and the reality of living on the edge of economic and social collapse. Common Ground examines the visual logic of bricolage and the aesthetic of fragmentation as each relates to the architecture of informal settlements. In these images the early idea of representing the dignity of the inhabitants of the informal settlements seem to have given way to deep skepticism, and the emergence of a surprisingly harsh realism. In fact, Mthethwa entirely avoids the cheerful interiors. Common Ground marks Mthethwa's first proper engagement with situations of urban crisis outside of South Africa. One part of the series derives from images Mthethwa produced in informal settlements in South Africa; the other, from post-Katrina photographs made in New Orleans. By eschewing any focal point, he consciously rendered these images ambiguous. The fact that we are unable to fix the images to a specific place heightens the ambiguity; they collapse into each other, and seem to explore the same pictorial continuum of urban decay. Perhaps this is the point: combining images of spaces occupied by marginalized Africans in South Africa and those of the neglected neighborhoods occupied by African-Americans in post-Katrina New Orleans drives our atten-

tion here to concerns for how black life tends to fare under situations of social inequality.

Mthethwa's images of children scavenging scraps on landfills in Contemporary Gladiators are of the same piece, as are those of strip miners in Mozambique, which are tentative, distant, and lack the focus and precision of his earlier work. In this work, Mthethwa deviates from a method more natural to his pictorial concerns, in which portraiture is the central feature. Instead, these bleak images appear as concessions to the documentary work he had previously avoided. This documentary turn appears ill suited to the careful compositional control that made Mthethwa's previous portrait works exercises in magisterial realism.

Labor, Landscape, Industry

Mthethwa's evident departure from the style of his Interiors portraiture series, and his foray into the abyss of documentary realism, expose a smudged gap of interpretation between his concerns. At this juncture, fine arts photography and reportage are uncomfortably imbricated. For Mthethwa, initially, color photography was a means to address this discomfort, to sever the ties between them. Color, it appeared, restored life and presence to those whom the harshness of reportage had transformed into ghosts and news. Moreover, he believed that the purpose of his work was to dissociate it from the creeping forms of afro-pessimism[28] that haunt the images of African subjects according to the law of reportage. But from the outset, the distinction between the frames of reportage and the serene pictorial order of fine arts photography was not as clear and obvious as he may have thought, and the line between objectified subjects and artistic intentions quickly blurred, as the images in his Contemporary Gladiators and Mozambique series show. Even if the pictorial scale of large-format color photography may have elevated lowly subjects to the height of iconic glamour, there remained the simple matter of these subjects resembling the characters often associated with reportage.

Parsing the difference between photographic genres, as Mthethwa imagined his work to have done, did at times bump against some resistance, as Coombes reminds us. Similarly, Bronwyn Law-Viljoen writes, "There is always that overused word 'dignity' to fall back on in describing the mingled pride, physical presence, and tiredness of the worker, as if the photograph, or our looking at it, confer this quality upon the subject."[29] Given this doubt, how might large-scale photography of the kind employed by Mthethwa organize a different temporality of the image, as well as articulate a space of pictorial reception in order to overcome the limits of documentary realism? How might it produce images that establish the singularity of social subjects, even those positioned on the lower rungs of the economic ladder? Two related projects, the Sugarcane, 2003, and Goldmine, 2005, series, address these queries. The majestic portraits that are the result of this engagement explore key issues in South African history and representation, especially the relationship between black labor, landscape, and industry. Though images of the Goldmine series register Mthethwa's compositional control, his photographs of the mineworkers posed in front of various machinery merely hint at the powerful critical appraisal exhibited in the Sugarcane portraits.

The Sugar Cane series is a tour de force of portraiture. Few contemporary works can match the power and grandeur Mthethwa brought to this series. He casts a probing yet sympathetic eye on the men he photographs, without dispossessing them of mystery. Part of his focus is on land, the other on manual labor and agricultural production. These images draw out the quandary of the black workers, especially their tenuous situation on the land. Mthethwa places the workers spatially, bracketing them between topography and cultivated nature, landscape and economic values. By buffering the laborers between these historically contingent ideas, Mthethwa's project itself goes beyond the articulation of land and landscape and the laborers' situatedness in them. It cannily operates, also, within an archaeological space, in order to excavate, and therefore probe, the social logic and economic dimension of colonial land practices and the apartheid policies that subtend them.

Surrounded by the vastness of the outlying space, and the claustrophobia of the dense sugarcane fields, the portraits of the laborers lead us through an imaginary adventure, not just into the meaning of the space in which they are momentarily fixed but also into how space and landscape have been fashioned and interpreted over time. The sugarcane fields and the surrounding landscape are therefore no ordinary aspects of nature; they represent deeply entangled notions of dwelling, history, memory, myth, ideology. In fact, the intertwined issues that overlay the shifting

themes in the images are especially resonant in situations where black labor intersects with white economic power, and in locations where landscape exposes the juridical mechanisms adapted by colonial modernity and apartheid structures to override African claims to, and presence on, the land.[30] In South African spatial politics, the black figure was always the antimodern. And in the open African landscape this figure was often perceived as a threat to colonial modernity's ideology of *terra nullis*, the idea that colonized space was devoid of human presence. That it was, a priori, empty. At the same time, the presence of these workers on the vast holdings of land, no doubt still employed on subsistent remuneration, raise paradoxical issues around the seemingly changed context of postapartheid transition.[31]

All these concerns are deeply entangled in the portraits, a group of images in which grim-faced black laborers, hidden behind implacable, almost uncommunicative detachment and deadpan seriousness, are positioned in the pit of the sugarcane harvesting industry and landscape. One notices immediately the discontinuity between the implements afforded the laborers—short, sharp-bladed machetes—and the industrial scale of the work before them, as if entirely subordinated to the land, thus heightening the sense of their alienation from the land. This sight offers a play of pictorial contrasts, between the blackened, callused hands wielding the machetes, the raw devastation of the cut sugarcane spread about in heaps of yellow stalks, and the cultivated outline of the fields that disappear out of sight, opening out from the incinerated, ravaged ground to the curls of smoke—as the fields are burned—and into the soft curves of the outlying green landscape, distant hills, and horizon. Here, we see the line between nature and industry being negotiated. These magisterial portraits of single figures, attired like medieval warriors in greasy smocks, flowing skirts, and gumboots and wielding long-handled knives, present the laborers in various poses, standing amid the devastation of the burned sugarcane fields, their back to the gently rolling cultivated land, against the backdrop of dappled, open blue sky. These powerful images surpass any work Mthethwa had produced to date.[32] It is a work of enormous ambition, whose epic formalism combines the pictorialism of nineteenth-century photography and the sublime composition of arcadian landscape painting.[33]

Claude Monet's Haystack paintings immediately come to mind in the way Mthethwa has organized the composition of these pictures. But these photographs, in terms of composition, structure, and subject matter recall the rural scenes of the French nineteenth-century realist painter Jean-François Millet, and his allegorical representation of the farm, labor, and the rustic countryside. Millet's realism depicted not only the naturalistic nature of the countryside and its surrounding landscape, but equally, a powerful, sensitive empathy toward the laborers in the center of his compositions. In the same way, Mthethwa employs a similar perspectival approach to construct how we see and perceive his photographs in relation to landscape and labor and his depiction of each individual worker. Each photograph heightens our awareness of both the figures and the spaces around them. What we see immediately and simultaneously before us are the two basic elements that make up his compositional and discursive devices: the contrast between the severity of the laborers' demeanor and the soft picturesqueness of the surrounding southern KwaZulu-Natal landscape. Mthethwa is clearly cognizant here of the raw, intransigent energy flowing from the laborers and the sublime, mythic power of the vistas offered by the rolling hills. Law-Viljoen captures this energy and power succinctly when she observes that "Mthethwa is alive to the mythological resonance of the landscape in which he is at work, with its fires and strangely-garbed characters, and its place in literary and cultural traditions, but he is quietly working away at the assumptions, some of them his own, that shore up this mythology."[34] Indeed, Mthethwa's way of positioning his subjects in the frame is an important element in his attempt to strip away this mythology and its accreted distortions. The laborers are by no means part of this mythology. In fact, they are the living embodiment of its perniciousness. Though the figures are firmly in place in the images, they are at the same time placeless on the ground they occupy, which highlights their vulnerability and exposes the helotry of their circumstances. To convey some of these qualities, Mthethwa uses different positioning strategies, placing the laborers within compositional frames that help build up points of reference. For example, in several images there are no vistas, no view of the sprawling arcadian landscape, only figures surrounded by the thick brambles of the sugarcane. In one image (p. 45), a young man in a pair of greasy shorts, wearing gumboots and a jauntily placed cloth hat covering his left eye, stands cross-armed, right leg placed forward and supported by the weight of his left leg. Against the backdrop of the green blades of the sugarcane crop, however, his confident stance,

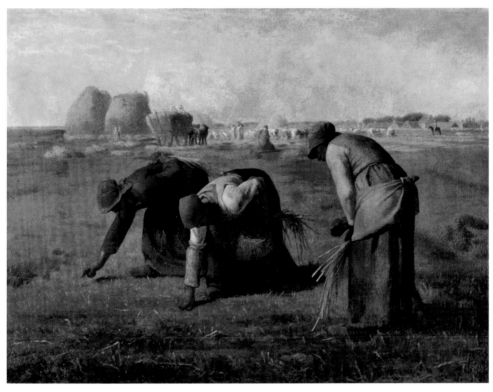

Jean-François Millet, *The Gleaners*, 1857

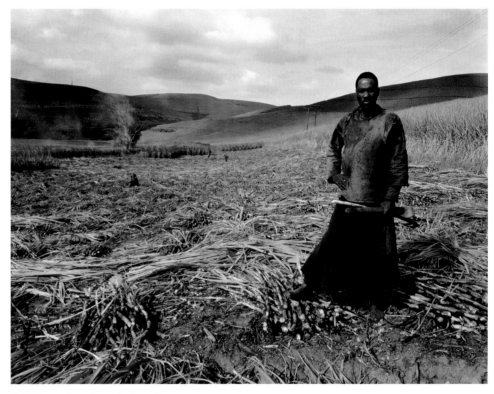

Untitled, 2007, from the series Sugar Cane

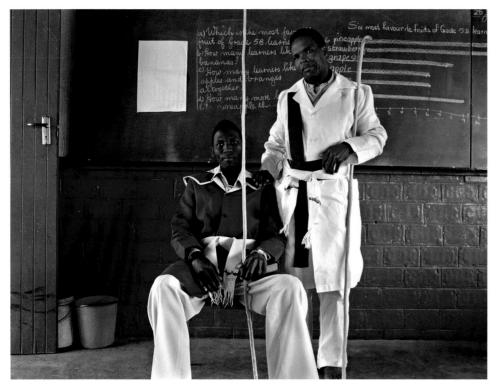

Untitled, 2006, from the series Churches

even bravado, seems rather tentative and exaggerated. For he is in fact hemmed in, trapped by the thick bush closing in on him, the sharp serrated leaves threatening to envelop and swallow him. In other images one figure squats in the middle of a field of burned and cut cane and its sticky black ooze; while in another image (p. 43), a man stands in the middle of the burned-out embers of the cane crop, his machete held aloft across his shoulders with black-stained hands, while the remnants of the cane waver in the wind. Yet another figure is positioned in the right corner of another picture, where he stands, left hand on hips, a scythe hoisted across the right shoulder. However, this self-assured stance is unsettled by the force of opposing movements in the picture: on one side the yellowed stalks move in a sweep toward the left side, while the figure is pulled to the opposite end of the picture. These placements remind the viewer that inasmuch as the subjects have a degree of autonomy, they are nevertheless contained and embedded deep within the logic of their labor. One photograph (p. 41) in particular underscores this fact: it depicts a hooded man, cloaked in smudged red skirt and blackened smock, standing with his back to the remaining crop, as he holds in his blackened left hand his machete. He appears to have stopped momentarily—left leg placed front, while his hip falls backward toward the unfinished harvest—to have his picture taken, as if merely honoring a request. He stoically regards the photographer with neither hostility nor invitation; his face betrays no emotion, just a steady, ungiving gaze.

This group of images encircles the subjects, manifesting a kind of pictorial claustrophobia. Against this encirclement, Mthethwa devised two other frames. In one of them the figures are positioned dead center, in the middle of the photograph, framed by a semicircle of the surrounding crop and landscape. One such image depicts a man in the middle of the photograph, his back to the sun, which gives his shadowed face a forlorn, shaded look. The man seems not fully engaged with the photographic session. But he nevertheless gives himself, almost perfunctorily, to the exercise, his shoulders slightly slack, the machete rested gingerly on the right shoulder, while he balances his weight on a staff held to the ground in his left hand. His right foot rests on top of a rock at the base of which lies a gathered bundle of cut cane. To the sides, spread to left and right, lie neat rows of shirred leaves and more bundles of the cane. Behind him, a spreading veil of smoke delineates the surrounding landscape, which

declines to a vanishing point at the top of the hill, showing the faint outlines of electric pylons. In succession, other men are placed in similar tableaus of landscape and space beyond. Each man stands, squarely in the middle, back to the sun and the distant hills and valleys. Mthethwa takes his time lingering on the profiles of the men. And one after the other they step forward and take their place in defiance (p. 48), like the man with the upswept hair in a ripped, cut-off shirt and red skirt, or in resignation, like the turbaned man holding his machete and staff on the ground (p. 43).

Relatedly, Mthethwa placed the men at the corners of the photograph—on the left and the right. He uses these positions to mark a transition between planted fields and the surrounding hills and valleys. In fact, he has employed this positioning at the corners in order to delineate and cut a boundary between the sweep of unharvested landscape to one side and the harvested field on the other. Of these, the powerful image of a young, enigmatic figure, placed on the rise of a slight ridge that sweeps leftward in a surge of flattened crop (p. 39), demonstrates a virtuosic articulation of the relationship between man and nature. Here, the man leaning on his machete stands as a domineering figure, a picture of arrogant disposition, an unmistakable contentment registered on his half-illuminated face.

In conclusion, taken together, from the early pastel drawings that trafficked in the clichés of rural and township life, simplified for profitable consumption by those who want their black images a certain shade of sunny sweetness, turning to the absorbing large-scale color photographs of interiors, then finally to the magnificent portraits of the mineworkers and sugarcane laborers, Mthethwa, finally, was able to traduce the simplistic morality of black-and-white reportage. But this is not a matter of cocky violation of pictorial convention, nor an arrogant retort to documentary realism. Rather, the relationship he sets up between diverse systems of representation and modes of picturing that structure the existence of his subjects makes his images specific to the individuals portrayed. It drives at the core of their humanity. The result are photographs that are expressive of the values of *ubuntu*, which shifts the scales from the merely celebratory to a nuanced kind of salutary picturing of people rarely visible in the optics of social prestige.

These images concentrate our attention on that divide between the sensationalized images of privation and violence and the saccharine denouement that resists addressing it. In the sweeping gestures of his images, Mthethwa does not so much overcome this dichotomy as combine and reveal their entanglement, and show how the entanglement still haunts the picturing of the inhabitants of his troubled society. At the same time, he challenges conventional ideas of the black subject as a ground-down, dispossessed, disempowered, and abject figure in need of social sympathy. The various series, as a collection, offer an inquiry not only into the crisis of dwelling and habitation that besets the black populations of post-apartheid South Africa but also into the production of citizenship and sovereignty, land and labor. His grand images present the emancipatory possibility of color; its ability to infuse life into beleaguered communities, and to speak persuasively of the dignity of the subjects in the face of their entrapment, and also of their ardor, resilience, and courage. Mthethwa more than amply realizes his ambition to clear the ground, to begin anew, if not necessarily in service of *fine arts* photography, then at least toward a kind of photography after the end of documentary realism.

San Francisco, February 2009

Notes

1. Black-and-white documentary photography was often a target of the critique that what it tended to portray of life under apartheid exploited the system, rather than inform a deeper understanding of how the society engaged the challenge of resisting it.

2. Of the different kinds of documentary-style photographic production, forms of reportage that end up in the mass media across the world have been constantly charged with sensationalism and with limiting the scope of what they document and the events they cover.

3. Njabulo Ndebele, *Rediscovery of the Ordinary: Essays on South African Literature and Culture* (Johannesburg: COSAW, 1991), p. 46.

4. During the years of apartheid, advanced cultural production in South Africa could be divided into two camps: the first, that of socially conscious art, what Ndebele refers to as preferring exteriority rather than interiority. In this camp one would find artists such as Athol Fugard, John Kani, Nadine Gordimer, William Kentridge, Sue Williamson, Gavin Jantjes, and Helen Sebidi, among others. The second camp was comprised of forms of art that approached representation from a more oblique, nuanced angle and privileged a more analytical mode. Amongst such artists are Durant Sihlali, Ezrom Legae, J. M. Coetzee, David Goldblatt, and Jane Alexander. Following the June 16, 1976, Soweto uprising and disturbances across the country and the death of Black Consciousness leader Steve Biko in detention, there was a clear rise in politically explicit art making. In the 1980s, under the state of emergency declared by the government of P. W. Botha, and with the rising challenge to the system and security forces by antiapartheid activists, artists across disciplinary lines adopted the trope of "Resistance Art" as an explicit response to apartheid. Resistance Art articulated the point that in an abnormal society such as South Africa was, art and artists cannot remain neutral. The modernist notion of artistic autonomy was deemed secondary to the idea of social responsibility in the belief that politically committed art is as essential to liberation as protest marches on the street. It was during this decade that social-documentary–style photography gained increasing prominence.

5. Colin Richards, "Aftermath: Value and Violence in Contemporary South African Art," in *Antinomies of Art and Culture: Modernity, Postmodernity, Contemporaneity*, ed. Terry Smith, Okwui Enwezor, and Nancy Condee (Durham, N.C.: Duke University Press, 2008), p. 259.

6. Though he is better known internationally for his large-scale color photography, which often depicts black subjects in so-called informal settlements, Mthethwa has not completely abandoned his work in pastel. This body of work, however, is mostly shown locally in South Africa, raising the issue of whether it is produced specifically for local audiences, particularly for the consumption of an emerging black elite who perhaps are not yet comfortable with the tougher subject matter of the color photographs.

7. Mthethwa earned his advanced diploma in fine art at the Michaelis School of Fine Art at the University of Cape Town and subsequently traveled to the United States on a Fulbright scholarship, obtaining an MFA from the Rochester Institute of Technology.

8. Interview with Rory Bester in *Democracy's Images: Photography and Visual Art After Apartheid*, ed. Jan-Erik Lundstrom and Katarina Pierre (Umeå, Sweden: Bildmuseet, 1998), p. 82.

9. Ibid.

10. *Ubuntu*, a Zulu word, roughly translates as "humanism." It was prevalent in many discussions surrounding South Africa's Truth and Reconciliation Commission process during the 1990s. It was deployed powerfully by Archbishop Desmond Tutu, cochair of the commission, to direct attention to the fact that the commission was not a tribunal, and that it recognizes the humanity of both the victims and the perpetrators of apartheid.

11. Quoted in Richards, "Aftermath," p. 260.

12. Emmanuel Levinas, *Entre Nous: Thinking of the Other*, trans. Michael B. Smith and Barbara Harshav (New York: Columbia University Press, 1998). See also Emmanuel Levinas, *Humanism of the Other*, trans. Nidra Poller (Urbana-Champaign: University of Illinois Press, 2006).

13. I have explored this vexed relationship, especially the manner in which the image of the black African subject was deployed in the work of a number of white South African artists in the 1990s. See Okwui Enwezor, "Reframing the Black Subject: Ideology and Fantasy in Contemporary South African Representation," *Third Text*, no. 40 (Autumn 1997): 21–40.

14. The Group Areas Act was enacted in 1950 by the parliament as a means of legalizing segregation according to South Africa's racial composition. It restricted different groups to specific areas of residence, business, and employment. The broader intention of the act was exclusionary; it sought to exclude blacks from the city, placing them in the far outskirts of developed urban areas and therefore effectively denying all access to the city.

15. The Separate Amenities Act was enacted in 1953. It provided specifically for the legal segregation of public facilities, including institutions, transportation, and so on, according to race and ethnicity.

16. The *dompas* preceded both the Group Areas Act and Separate Amenities Act. It was introduced in 1923 as a kind of internal passport that allowed or disallowed the presence of nonwhite individuals in urban areas and cities.

17. Rory Bester, "City and Citizenship," in *The Short Century: Independence and Liberation Movements in Africa, 1945–1994*, ed. Okwui Enwezor (Munich: Prestel Verlag, 2001), p. 219.

18. Ibid.

19. Ibid.

20. Michael Godby suggests that Mthethwa plays a directorial role in this regard. He writes, "Moreover, some photographs suggest that the photographer himself has composed certain aspects of the interior: in one, a drab-colored carpet has been pushed to one side to reveal a bright linoleum floor-covering beneath; and, in others, crisp new tablecloths and blankets suggest that they have been arranged for the occasion." See Michael Godby, "The Drama of Color: Zwelethu Mthethwa's Portraits," *Nka: Journal of Contemporary African Art*, no. 10 (Spring/Summer 1999): 49.

21. This image, along with Mthethwa's other experiments with color photography, was publicly exhibited for the first time in 1997 at the second Johannesburg Biennale. In the Biennale, the author and his cocurator Octavio Zaya, after making a studio visit to Mthethwa's office at the Michaelis School of Fine Art, at the University of Cape Town, in early 1997, selected a group of twenty-four photographs for the exhibition *Alternating Currents*, later that year in October. See *Trade Routes: History and Geography*, ed. Okwui Enwezor (Johannesburg: Greater Johannesburg Metropolitan Council/Amsterdam: Prince Claus Fund, 1997), pp. 158–59.

22. As Michael Godby notes, "Mthethwa makes no attempt

to conceal the poverty of his subjects or the precariousness of many of the structures whose colorful furnishings he celebrates." Godby, "Drama of Color," p. 49.

23. One curious, and possibly contradictory, fact about the portraits is that the sitters are never identified. All the portraits are generically untitled. Despite the sunny disposition of some of the images, the figures in them remain enigmas; the camera has not adequately revealed them to us.

24. Annie E. Coombes, *History After Apartheid: Visual Culture and Public Memory in a Democratic South Africa* (Durham, N.C.: Duke University Press, 2003), p. 190.

25. This type of pose reoccurs through much of Mthethwa's work, beginning with the pastels.

26. Perhaps one reason for the preponderance of beds in these interiors is that these are mostly single rooms, in which the bed is the central and dominant furniture. Most of these rooms are also quite small, and whatever space is left is crammed with the personal belongings of the occupants. And though sometimes the smallness of the rooms makes them claustrophobic, Mthethwa manages to reverse this effect by making them appear intimate, almost like sanctuaries. In a fundamental way, these dwellings are indeed sanctuaries from the difficult life of labor the occupants live.

27. A pervasive difficulty for successive postapartheid South African governments centers on issues of housing and access to land, especially for millions of underhoused and underemployed in the country. Intermittent clashes between property owners or municipalities and squatters who occupy large tracts of land in which new informal settlements are erected are a chronic social and political problem.

28. I have elaborated elsewhere on the idea of afro-pessimism in relation to photography. See Okwui Enwezor, "The Uses of Afro-Pessimism" in *Snap Judgments: New Positions in Contemporary African Photography* (New York: International Center of Photography/Göttingen: Steidl, 2006), pp. 11–19.

29. Bronwyn Law-Viljoen, "Interrupting Mythologies," *Artthrob*, no. 80 (April 2004), www.artthrob.co.za/04apr/reviews/shainman.html.

30. The landmark Natives Land Act adopted by the all-white South African legislature in 1913 was an example of how the law helped construct the relationship of Africans to land. Basically, the act changed the terms of ownership of land, shifting it permanently, and irrevocably into the hands of white ownership.

31. Despite the political debacle of Robert Mugabe's seizure of land from white farmers in Zimbabwe, it remains clear that we are yet to see the end of the unraveling of colonial land policies fashioned during the period before national liberation brought Africans to power. With that shift in power came the desire to dismantle the apparatus of colonial modernity through forms of land redistribution. Though these issues are not specifically addressed in Mthethwa's work, given the fact that similar sentiments toward land have been percolating in South Africa for more than a century and have intensified since the end of apartheid, one cannot address art's relationship to landscape without observing the contested nature of land—an issue that has been subject to ideological populism—in postapartheid political discourse.

32. In an interview with Sean O'Toole, Mthethwa likens the men to Japanese samurai warriors. See Sean O'Toole, "In Conversation with Zwelethu Mthethwa," *Artthrob*, no. 83 (July 2004), www.artthrob.co.za/04july/news/mthethwa.html.

33. There are two important books useful for a deeper appreciation of the pictorial concepts that suffuse Mthethwa's images: Barbara Novak, *Nature and Culture: American Landscape and Painting, 1825–1875*, rev. ed. (New York: Oxford University Press, 2007); and Simon Schama, *Landscape and Memory* (New York: Vintage Books, 1995). For a study more specific to South Africa, see J. M. Coetzee, *White Writing: On the Culture of Letters in South Africa* (Sandton, South Africa: Radix, 1988).

34. Law-Viljoen, "Interrupting Mythologies."

Biography

Born in 1960 in Durban, KwaZulu-Natal, South Africa.

1979 Receives BA in pre-med at University of Zululand, before deciding to pursue a career in the visual arts.

1979 Attends Abangani Open School, Durban.

1981 Transfers to Michaelis School of Fine Art at the University of Cape Town, and develops interest in photography.

1984 Receives diploma in fine arts from Michaelis School of Fine Art.

1989 Receives MFA in imaging art at Rochester Institute of Technology, Rochester, New York, while on a Fulbright scholarship.

1994–98 Serves as lecturer in photography and drawing at Michaelis School of Fine Art.

1998–present
 Promoted to senior lecturer, then research associate, at Michaelis School of Fine Art.

Selected Solo Exhibitions

2009 *New Works*, Jack Shainman Gallery, New York

2008 *Children of a Lesser God*, Everard Read, Johannesburg

 Contemporary Gladiators, Andréhn-Schiptjenko, Stockholm

2007 *Zwelethu Mthethwa*, Galerie Anne de Villepoix, Paris

 Recent Work, Interiors and Sugar Cane, Galería Oliva Arauna, Madrid

 Maidens and *The Dance of Life*, Christine König Galerie, Vienna

2006 *Gold Miners*, Jack Shainman Gallery, New York

 New Works, Everard Read, Johannesburg

 Maidens, Galerie Hengevoss-Dürkop, Hamburg, Germany

2005 *Women in Private Spaces*, Andréhn-Schiptjenko, Stockholm

 Ticket to the Other Side, Galerie Hengevoss-Dürkop, Hamburg, Germany

2004 *Harvesting Workers*, Davis Museum and Cultural Center, Wellesley College, Wellesley, Massachusetts

 Lines of Negotiation, Jack Shainman Gallery, New York

 New Works, Association for Visual Arts, Cape Town

2003 *New Works*, Jack Shainman Gallery, New York

 Interior Portraits: Zwelethu Mthethwa Photographs, Cleveland Museum of Art

2002 *Women in Private Space*, Galerie Hengevoss-Dürkop, Hamburg, Germany

2001 *Private Spaces*, Goodman Gallery, Johannesburg

 Mother & Child, Marco Noire Contemporary Art, Turin, Italy

2000 *Sacred Homes—Mother and Child*, Palazzo delle Esposizioni, Rome

1999 Foto Biennale Rotterdam, Rotterdam, the Netherlands

 Triennale der Photographie, Galerie Hengevoss & Jensen, Hamburg, Germany

 Towards-transit, Zürich

Selected Group Exhibitions

2008–9

Prospect.1 New Orleans, New Orleans

Rethinking Landscape: Photography from the Collection of Allen Thomas Jr., Roanoke Museum, Roanoke, Virginia

Sharing Territories, Fifth São Tomé Bienal, São Tomé and Príncipe, Brazil

2008

People, Jim Kempner Fine Art, New York

Scratches on the Face, National Gallery of Modern Art, New Delhi; National Gallery of Modern Art, Mumbai

Brave New Worlds, Walker Art Center, Minneapolis

Planet Africa, Galerie Hengevoss-Dürkop, Hamburg, Germany

2007

Between Us—Entre Nous—Phakathi Kwethu, iArt Gallery, Cape Town

World Receiver: 10 Years Galerie der Gegenwart, Hamburger Kunsthalle, Germany

Existencias, Museo de Arte Contemporáneo de Castilla y León, León, Spain

Apartheid: El mirall sud-africà, Centre de Cultura Contemporània de Barcelona, Barcelona, Spain

South African Art: Modern Art and Cultural Development in a Changing Society, Danubiana Meulensteen Art Museum, Bratislava, Slovakia

So Close So Far Away, Centre Rhénan d'Art Contemporain, Altkirch, France

Defining Moments in Photography from the MCA Collection, Museum of Contemporary Art, Chicago

2006

Planet Afrika: Carte Blanche, AFRICOM stations in Berlin, Magdeburg, Essen, Wittenberg, Kirkel, and Frankfurt, Germany

The Living Is Easy, Flowers East, London

Black Panther Rank and File, Yerba Buena Center for the Arts, San Francisco

Black, Brown & White, Kunsthalle Vienna

Snap Judgments: New Positions in Contemporary African Photography, International Center of Photography, New York; Miami Art Central; Memphis Brooks Museum of Art; Stedelijk Museum, Amsterdam

The Whole World Is Rotten, Contemporary Arts Center, Cincinnati

Why Pictures Now, MUMOK Lounge, Museum Moderner Kunst, Stiftung Ludwig, Vienna

Cross-Currents in Recent Video Installation: Water as a Metaphor for Identity, Tisch Gallery, New York

Adelaide Bank Festival of Arts, Artists' Week 2006, Adelaide, Australia

2005

Emergencies, Museo de Arte Contemporáneo de Castilla y León, León, Spain

The Forest: Politics, Poetics, and Practice, Nasher Museum of Art at Duke University, Durham, North Carolina

The Experience of Art, Venice Biennale

New Work/New Acquisitions, Museum of Modern Art, New York

Green to Green and Beyond, Gallery W52, New York

A Passion for Pictures, North Carolina Museum of Art, Raleigh

Imprints: Works on Paper, Axis Gallery, New York

The Whole World Is Rotten: Free Radicals and the Gold Coast Slave Castles of Paa Joe, Jack Shainman Gallery, New York

Earth and Memory: African and African-American Photography, Elizabeth Stone Harper Gallery, Presbyterian College, Clinton, South Carolina

Prague Biennale 2

African Art, African Voices, Philadelphia Museum of Art

Common Ground: Discovering Community in 150 Years of Art, Corcoran Gallery of Art, Washington, D.C.

São Paulo Biennial, São Paulo, Brazil

Africa Remix, Hayward Gallery, London; Museum Kunst Palast, Düsseldorf; Pompidou Centre, Paris; Mori Art Museum, Tokyo; Centro Atlantico de Arte Moderno, Canary Islands; Moderna Museet, Stockholm; Johannesburg Art Gallery; Gwangju Biennale, Gwangju, South Korea

2004

Passaporto, Le Méridien Lingotto Art + Tech, Turin, Italy

Ipermercati dell'Arte, Palazzo delle Papesse, Siena, Italy

Made in Africa Fotografia, Musei di Porta Romana, Milan

Festival della Fotografia, British Academy, Rome

Festival Couleur Café, Tour et Taxis, Brussels

New Identities, Contemporary South African Art, Bochum Museum, Bochum, Germany

Postcards from Cuba, Henie Onstad Kunstenter, Oslo

Afritudine, Musei di Porta, Milan

Body and the Archive, Artists Space, New York

The Gift: Generous Offerings, Threatening Hospitality, Art Gallery of Hamilton, Ontario; Bronx Museum of the Arts; Govett-Brewster Art Gallery, New Plymouth, New Zealand; Scottsdale Museum of Contemporary Art, Scottsdale, Arizona

2003

Eighth Havana Biennial

Istanbul Biennial

Strangers: The First ICP Triennial of Photography and Video, International Center of Photography, New York

Prague Biennial 1

Portraiture (Every Picture Tells a Story), Solomon Projects, Atlanta

Sharjah International Biennale, United Arab Emirates

World Receiver, Hamburg Kunsthalle, Galerie der Gegenwart, Hamburg, Germany

2002

New Acquisitions/New Works/New Directions 3: Contemporary Selections, Los Angeles County Museum of Art

Staging: Janieta Eyre, Julie Moos and Zwelethu Mthethwa, Contemporary Art Museum, St. Louis

Untitled, Jack Shainman Gallery, New York

In Situ—Portraits of People at Home, Hand Workshop Art Center, Richmond, Virginia

Cultural Crossing, Numark Gallery, Washington, D.C.

Fuoriuso, Ferrotel, Pescara, Italy

Shopping: Art and Consumer Culture, Schirn Kunsthalle Frankfurt; Tate Liverpool, Liverpool, England

Tracing the Rainbow, Kulturverein Zehntscheuer, Rottenburg, Germany; Kunst: Raum Sylt Quelle, Sylt, Germany

Overnight to Many Cities: Tourism and Travel at Home and Away, Photographers' Gallery, London

Dis/location, Sala Rekalde, Bilbao, Spain

Sudafrica: la pittura, la fotografia, il cinema, Centro Trevi, Bolzano, Italy

Videoarte Africana, Twenty-fifth Bienal de São Paulo, São Paulo, Brazil

2001

I Love NY, Jack Shainman Gallery, New York

The Short Century: Independence and Liberation Movements in Africa 1945–1994, Haus der Kulturen der Welt, Martin-Gropius-Bau, Berlin: Museum of Contemporary Art, Chicago; Museum Villa Stuck, Munich; P.S.1 Contemporary Art Center, New York

A Passion for Art: The Disaronno Originale Photography Collection, Miami Art Museum; Museum of Contemporary Art, Chicago; New Museum of Contemporary Art, New York; Berkeley Art Museum and Pacific Film Archive, University of California, Berkeley

Africa Today, Centre de Cultura Contemporània de Barcelona, Barcelona, Spain

Boomerang: Collector's Choice, Exit Art, New York

Africa 2000: The Artist and the City, Centre de Cultura Contemporània de Barcelona, Barcelona, Spain

Overnight to Many Cities: Travel and Tourism at Home and Away, 303 Gallery, New York

The Gift: Generous Offerings, Threatening Hospitality, Art Gallery of Hamilton, Hamilton, Ontario; Bronx Museum; Govett-Brewtser Art Gallery, New Plymouth, New Zealand; Palazzo delle Papesse, Siena, Italy; Palazzo Candiolo, Venice; Scottsdale Museum of Art, Scottsdale, Arizona

TRADE: Wares, Ways and Values in World Trade Today, Fotomuseum Winterthur, Winterthur, Switzerland; Nederlands Foto Instituut, Rotterdam

FotoEspaña, Circulo de Bellas Artes, Madrid

Storia Contemporanea, Museo Civico di Bergamo, Bergamo, Italy

New Heimat, Frankfurter Kunstverein, Frankfurt, German

2000

Simultaneous, Jack Shainman Gallery, New York

A3HB, Camouflage, Brussels

Fun Five Fun Story, Art Gallery of New South Wales, Australia

A.R.E.A. 2000, Kjarvalsstadir, Reykjavik, Iceland

South Meets West, Kunsthalle Bern, Bern, Switzerland

Mirades Impúdiques, Fundació "La Caixa," Barcelona, Spain

Dire AIDS—Say AIDS, Palazzo della Promotrice delle Belle Arti, Turin, Italy

Dak'Art 2000, Dakar, Senegal

Paris pour escale, Musée d'Art Moderne de la Ville de Paris

Arts and Human Rights, Kwangju International Biennale, Seoul, Korea

Home, Perth International Arts Festival, Art Gallery of Perth Cultural Centre, Perth, Australia

Il sentimento del 2000, arte e foto: 1960/2000, La Triennale di Milano

Mostra Africana de Arte Contemporanea, Video Brazil, São Paulo, São Paulo, Brazil

Pusan International Contemporary Art Festival, Pusan, Korea

Foto Biennale Rotterdam, Rotterdam, the Netherlands

1999

Liberated Voices: Contemporary Art from South Africa, Austin Museum of Art; Iris and B. Gerald Cantor Center for Visual Arts at Stanford University, Stanford, California; Museum for African Art, New York; University of Arizona Museum of Art, Tucson

Looking for a Place, SITE Santa Fe, New Mexico

Dreams and Clouds: South African Contemporary Art, Göteborgs Konstmuseum, Göteborg, Sweden

«Rewind» Fast Forward.Za, Van Reekum Museum, Apeldoorn, the Netherlands

Images for Dignity, PhotoEspaña, Barcelona, Spain

Project Conflux, Galerie Tendances Mikado, Luxembourg

South Meets West, Kunsthalle Bern, Bern, Switzerland; National Museum, Accra, Ghana

Toward-Transit, New Visual Languages in South Africa, Pro Helvetia Art Council of Switzerland, Zürich

Staking Claims, Granary, Cape Town

1998

Five South African Artists, FotoFest 1998, Houston

A History of African Photography, La Maison Européenne de la Photographie, Paris

Africa, Africa, Tobu Museum, Tokyo

Democracy's Images: Photographs and Visual Art After Apartheid, BildMuseet, Umeå, Sweden

Klein Karoo National Arts Festival, Oudtshoorn, South Africa

Africa by Africa, Barbican Art Gallery, London

Yesterday Begins Tomorrow: Ideals, Dreams, and the Contemporary Awakening, Center for Curatorial Studies, Bard College, Annandale-on-Hudson, New York

Blank ….. State of Architecture + Urban Planning in South Africa, Netherlands Architecture Institute, Rotterdam

Architecture, Apartheid and After, Van Reekum Museum, Rotterdam, the Netherlands

1997

Lift Off, Goodman Gallery, Johannesburg

Trade Routes: History and Geography, Johannesburg Biennale

Photo Synthesis-Contemporary South African Photography, Grahamstown Art Festival, Grahamstown, South Africa

La Bohème: Noir, Primart Gallery, Cape Town

CRAM, Goodman Gallery, Cape Town

1996

Simunye: We Are One. Ten South African Artists, Adelson Gallery, New York

1995

World Economic Forum Group Show, Davos, Switzerland

Crosscurrents, Very Special Arts Gallery, Washington, D.C.

Africa 95, Bernard Jacobson Gallery, London

Artists for Peace '95, Palais des Nations, Geneva

1994

Crosscurrents, Barbara Gillman Gallery, Miami Beach

1993

Grand Prix International d'Arts Plastiques, Nice, France

Abidjan Biennale, Abidjan, Ivory Coast

Selected Bibliography

Basualdo, Carlo. "Launching Site." *Artforum*, Summer 1999, pp. 39–40, 42.

Cameron, Dan. "Looking for a Place: SITE Santa Fe." *Artforum*, November 1999, p. 140.

Camhi, Leslie. "Darkness Visible." *Village Voice*, March 29, 2002.

Cochrane, Gail, and others, eds. *Dire AIDS: arte nell'epoca dell'AIDS/Dire AIDS: Art in the Age of AIDS*. Milan: Charta, 2000.

Cotter, Holland. "Zwelethu Mthethwa." *New York Times*, June 16, 2000, p. E33.

-----. "Scenes of Colonial Africa with Racist Overtones." *New York Times*, February 14, 2003, p. E44.

Cotton, Charlotte. *The Photograph as Contemporary Art*. London: Thames & Hudson, 2004, p. 175.

Dhlomo, Bongi. "Zwelethu Mthethwa Talks About His Photographs." In *Liberated Voices: Contemporary Art from South Africa*, edited by Frank Herreman. New York: Museum for African Art, 1999, pp. 66–75.

Enwezor, Okwui. *Snap Judgments: New Positions in Contemporary African Photography*. New York: International Center of Photography; Göttingen, Germany: Steidl, 2006.

Enwezor, Okwui, ed. *The Short Century: Independence and Liberation Movements in Africa, 1945–1994*. Munich/New York: Prestel, 2001.

Fibicher, Bernard, et al., eds. *South Meets West*. Bern, Switzerland: Kunsthalle Bern, 1999, pp. 94–95, 115.

Firstenberg, Lauri. "Representing the Body Archivally in South African Photography." *Art Journal* 61 (Spring 2002): pp. 58–67.

Fresh Cream: Contemporary Art in Culture, 10 Curators, 10 Writers, 100 Artists. London: Phaidon, 2000.

Godby, Michael. "The Drama of Color: Zwelethu Mthethwa's Portraits." *Nka: Journal of Contemporary African Art* 10 (Spring–Summer 1999), pp. 46–49.

Great 41. London: Photographers' Gallery, 2002.

Hengevoss, Kerstin, and Zwelethu Mthethwa. *Zwelethu Mthethwa*. Hamburg, Germany: Galerie Hengevoss & Jensen, 1999.

Jenkins, Mark. "'Insights' Into Faraway Lands." *Washington Post Weekend*, March 26, 2004, p. 61.

Judin, Hilton, and Ivan Vladislavić, eds. *Blank—Architecture, Apartheid and After*. NAI: Rotterdam; New York: D.A.P./ Distributed Art Publishers, 1998.

Kellner, Clive. "Africa All Over." *Flash Art*, May/June 2000, p. 57.

Kimmelman, Michael. "The Gaze Turns Outward and Sees Estrangement." *New York Times*, September 19, 2003, p. E33.

Lindsey, Emma. "Shout of Africa." *Observer*, February 13, 2005.

The Living Is Easy: International Contemporary Photography. Essay by Anthony Downey. London: Flowers East, 2006.

Lundström, Jan-Erik, and Katarina Pierre. *Demokratins Bilder: Fotografi och Bildkonst efter Apartheid/Democracy's Images: Photography and Visual Art After Apartheid*. Umeå, Sweden: Bildmuseet, 1998.

Macrì, Teresa. *Postculture*. Rome: Meltemi, 2002, pp. 122–24.

Martinez, Rosa. "Cityscape on New Feminism." *Flash Art*, October 2000, pp. 53–56.

Mirades Impúdiques: Foto-Video-Film-Websites. Barcelona, Spain: Fondació "la Caixa," 2000.

Mitchell, Charles Dee. "Report from Santa Fe: Places of the Art." *Art in America*, December 1999, pp. 46–49, 51.

Mosaka, Tumelo. "Liberated Voices: Contemporary Art from South Africa." *Nka: Journal of Contemporary African Art* 11–12 (Fall/Winter 2000): pp. 104–7.

Mostra Africana de Arte Contemporânea. São Paulo, Brazil: SESC Pompéia, 2000.

Nairne, Sandy, and Sarah Howgate. *The Portrait Now*, New Haven, Connecticut: Yale University Press, 2006.

Oguibe, Olu, and Okwui Enzewor, eds., *Reading the Contemporary: African Art from Theory to the Marketplace.* Cambridge, Massachusetts: MIT Press, 1999.

Palazzoli, Daniela. *Il Sentimento del 2000: Arte e Foto: 1960/2000.* Milan: Electa, 1999.

Paris pour escale. Paris: Paris-Musées, 2000.

Pollack, Barbara. "The Newest Avant-Garde." *ARTnews,* April 2001, pp. 124–29.

-----. "When South Africa Joined the World, and the Art World." *New York Times,* March 9, 2003, p. AR19.

Princenthal, Nancy. "Forty Ways of Looking at a Stranger." *Art in America,* December 2003, pp. 42–45.

Reality-check: 2. Triennale der Photographie, Hamburg, 2002. Hamburg, Germany: Christians, 2002.

Rites Sacres, Rites Profanes: Ves Rencontres de la Photographie Africaine, Bamako 2003. Paris: Éditions Eric Koehler, 2003.

Rugoff, Ralph. "Global Art Reaches Santa Fe." *Financial Times,* July 31/August 1, 1999.

Salgado, Gabriela. "Eighth Havana Biennial: The Bittersweet Taste of Utopia." *Flash Art,* January/February 2004, pp. 47, 56.

Sewell, Brian. "Out of Africa." *London Evening Standard,* February 18, 2005.

Schmerler, Sarah. "Zwelethu Mthethwa at Jack Shainman." *Art in America,* January 2001, p. 108.

Seelig, Thomas, Urs Stael, and Martin Jaeggi, eds. *Trade: Commodities, Communication, and Consciousness.* Zurich: Scalo, 2002, pp. 272–75.

Shimizu, Toshio. *Africa Africa.* Tokyo: Tobu Museum of Art, 1998.

Smith, Trevor, Gary Dufour, and Thomas Mulcaire. *Home.* Perth, Australia: Art Gallery of Western Australia, 2000.

Spring, Christopher. *Angaza Afrika: African Art Now.* London: Laurence King, 2008.

Subirós, Pep. *Apartheid: The South African Mirror.* Barcelona, Spain: Centre de Cultura Contemporània de Barcelona, 2007.

Tilkin, Danielle. *Dislocation: Image and Identity, South Africa.* Madrid, Spain: La Fabrica, 2002, pp. 56–61.

Turner, Grady T. "Report from the U.A.E.: Fast Forward on the Persian Gulf," *Art in America,* November 2003, pp. 86–89, 91.

Vine, Richard. "Report from Mali: The Luminous Continent," *Art in America,* October 2004, pp. 68–71, 73.

Wendl, Tobias, ed. *Afrikanische Reklamekunst.* Wuppertal, Germany: P. Hammer, 2002, pp. 90–91.

Williamson, Sue. "Staking Claims: Confronting Cape Town," *Nka: Journal of Contemporary African Art* 11–12 (Fall/Winter 2000): pp. 92–95.

Zaya, Octavio. "Zwelethu Mthethwa: Styles and Desires of People Living on the Margins of Urban Culture." *Flash Art,* October 1999, pp. 90–91.

-----. "Identity Webs," In *Zwelethu Mthethwa.* Turin, Italy: Marco Noire Editore, 1999.

Zwelethu Mthethwa. Turin, Italy: Marco Noire Editore, 1999.

Selected Public Collections

Arco Foundation, Madrid

Mary and Leigh Block Museum of Art, North Western University, Chicago

Cape Department of Education Trust, South Africa

Daimler Chrysler Collection, Germany

Corcoran Gallery of Art, Washington, D.C.

Durban Art Gallery, KwaZulu-Natal, South Africa

Guggenheim Museum, New York

Samuel Harn Museum, Miami

Johannesburg Art Gallery

Herbert F. Johnson Museum of Art, Cornell University, Ithaca, New York

Kunsthalle Hamburg, Hamburg, Germany

LaSalle Bank, Chicago

Los Angeles County Museum of Art

Museum of Modern Art, New York

Museum Moderner Kunst Stiftung Ludwig, Vienna

Museo de Arte Contemporáneo de Castilla y León, Madrid

National Museum of African Art, Washington, D.C.

New Museum, New York

North Carolina Museum of Art, Raleigh

Centre Pompidou, Paris

Pretoria Art Museum, Pretoria, South Africa

San Francisco Museum of Modern Art

South African Embassy, Washington, D.C.

South African National Gallery, Cape Town

Stellenbosch University, Stellenbosch, South Africa

Studio Museum in Harlem, New York

Tatham Art Gallery, Pietermaritzburg, South Africa

University of the Witwatersrand, Johannesburg

Front cover: *Untitled*, 2000, from the series Interiors
Back cover: *Untitled*, 2003, from the series Sugar Cane

Guest editor: Isolde Brielmaier
In-house editor: Joanna Lehan
Designer: Francesca Richer
Production: Matthew Pimm

The staff for this book at Aperture Foundation includes:
Juan García de Oteyza, *Executive Director*; Michael Culoso, *Chief Financial Officer*; Lesley A. Martin, *Publisher, Books*; Jenny Goldberg, *Assistant to the Publisher*; Susan Ciccotti, *Senior Text Editor, Books*; Nima Etemadi, *Editorial Assistant*; Andrea Smith, *Director of Communications*; Kristian Orozco, *Sales Director*; Kellie McLaughlin, *Director, Limited-Edition Photographs*; Maria Laghi, *Director of Development*; Alex Freedman, Matt Minor, Ellen Stavro, *Work Scholars*

First edition
Printed in Singapore
10 9 8 7 6 5 4 3 2 1

Library of Congress Control Number: 2009928486
ISBN 978-1-59711-113-3

Aperture Foundation books are available in North America through:
D.A.P./Distributed Art Publishers
155 Sixth Avenue, 2nd Floor
New York, N.Y. 10013
Phone: (212) 627-1999
Fax: (212) 627-9484

Aperture Foundation books are distributed outside North America by:
Thames & Hudson
181A High Holborn
London WC1V 7QX
United Kingdom
Phone: + 44 20 7845 5000
Fax: + 44 20 7845 5055
Email: sales@thameshudson.co.uk

aperturefoundation
547 West 27th Street
New York, N.Y. 10001
www.aperture.org

The purpose of Aperture Foundation, a non-profit organization, is to advance photography in all its forms and to foster the exchange of ideas among audiences worldwide.